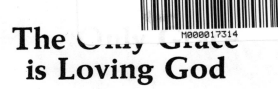

The Only Grace is Loving God

A Statement About the Sacred Message and
Ultimate Teaching Work of Lee Lozowick

The Only Grace is Loving God

Lee Lozowick

HOHM PRESS/PRESCOTT VALLEY, ARIZONA

Manufactured in the United States of America
International Standard Book Number: 0-934252-07-6
Library of Congress Catalog Card Number: 82-81992
Published by Hohm Press, P.O. Box 5839, Prescott Valley, Arizona 86312

Cover photo credit: Joseph Martin/Editorial Photocolor Archives, Inc.
Persian Miniature: Layla seated on the domed balcony of her house,
Free Public Library of Philadelphia.

FOREWORD

For the Hindus, it is Krishna or Rama. For the Sufis, it is the Guest, the Beloved. For Christians, it is Jesus. The Names of God among men are countless, like pearls strung on a thread, but wherever true religion arises, that thread is always the same: the love and worship of the Divine Person.

It is this worship that the spiritual Master Lee Lozowick refers to as Loving God. It is the Way of life that he Teaches and recommends, and so you will find that this book is an exhortation, a call to worship, rather than an abstract treatise on the Divine.

The Love of God is an embarrassing or confusing subject for many people today. The ancient images of the personal deity have been ridiculed and toppled by the advance of the scientific mode of thinking, denied as primitive and unnecessary. While religion and spirituality are enjoying something of a rebirth in this country, in a wide variety of forms, the worship of the Personal Divine is not often a part of it.

Many individuals are involved in the quest for personal transformation, or enlightenment, but if God is made mention of in such approaches, it is usually in an impersonal sense, as a power or force, or as a mere metaphor for the absolute, the highest attainment possible to man.

The vision presented in this book, therefore, is an unusual one in this time and place. While Lee Lozowick does not deny the value of personal growth, or the reality of the impersonal Absolute — the Divine Energy that manifests as and pervades the cosmos — he nonetheless puts forth the uncompromising argument that the highest possibility and direction for a human life is love, worship, and surrender to the Person of God. He urges us to abandon our work on ourselves, and every kind of personal concern, to the point of mad, passionate, total loving absorption in the One who reveals

himself to us as the Beloved.

There is a paradox here, of course. Loving God, as the Master refers to it, is not the conventional religious effort to kindle a flame in the heart, or to find a communication from an Other which convinces us of his reality. Loving God is purely a gift — the only Gift — and cannot be gained through any effort or process. It is bestowed randomly, and only upon those who have already matured in the natural unfolding of spiritual life, those who have already surrendered to the Divine as the totality of existence.

And yet, God is compassionate. Those who desire to love him wholly, to know only him, may be given a taste of the Gift. Lee Lozowick is such a man, and he points all who would listen in that direction.

Loving God, he freely confesses, is madness. It is something only a lover would do. There is no reasonable argument for it. Loving God stands apart from any destiny, mortal or Divine, and is the only Gift, the only Grace, and the only Freedom. For one who Loves God is free, even of the Laws of existence, even of the Will of God. Such a one expresses the magnificent, capricious, joyful, humorous Whim of God. To be human is to love, and to Love God is to be perfectly human. The lover dances wildly with his Beloved, seeing only the beauty of that One, all else beyond noticing.

This is the possibility to which this book invites you.

INTRODUCTION

How do you tell someone about the consideration of Loving God, which in itself is nearly inconsiderable? Do you describe the process that leads to this way of living? Do you attempt to define Loving God so that all may clearly understand what it is? Do you give a person plain and practical instructions on how to attain this state?

I know little of these questions, so it is impossible for me to attempt to answer them in any way. However, from being a student of Lee Lozowick, who is here offering the consideration that Loving God is the *only* Grace, and from barely beginning to grasp this consideration myself, I can say this: that the possibility of Loving God is inconceivable, sacred and absolutely necessary, and forms the foundation for real spiritual practice. All who are even remotely interested in God, religion, enlightenment, or the meaning of human existence owe it to their interest to read this book and test this consideration for themselves.

It is not that this book will answer any of your questions, though some will feel that this is the case. Others may end up with more questions than when they began. Ultimately, the consideration of Loving God leaves all such questions behind. They can only serve as pointers, since questions, or answers, cannot begin to contain the immensity of what it means to even think about Loving God. By the time you reach the point where you are actively reflecting on Loving God, you may find that your questions have disappeared into the vastness of this proposal.

Nowhere else will you find this teaching made available — not that it is a particularly new or previously undiscovered fact of existence. In fact, it is at the heart of all true religion and spiritual life, and is the great secret of all spiritual Masters who have been Lovers of God. But it is the one essential aspect of living religious teaching that is often missed in the distractions of daily practice and ritual, and is the one aspect

that all spiritual aspirants so desperately need to hear. With it, spiritual practice is alive, ordinary, and jubilant; without it, spiritual practice is a lot of work and not much fun.

Let this book engage you. If you begin at all to really think about what it means to Love God, it may well be the most wild, dangerous, profound and ridiculous thing that you will ever do with your life.

But it will also be the most worthwhile.

For so long I sought riches,
 and found much wealth
Till I discovered You,
 a Beggar
And now seek only the Poverty
 you so regally bear
To be as Poor as you,
 Beloved Guru
Is a blessing I only dream of,
 with awe
So sings Lee, his wealth effaced
 in the Poverty of his Lord
May this only be so

The understanding of Loving God, the extraordinary and profound glory of the distinction between the Will of God and the Whim of God, may be more clearly shown by the knowledge that Awakening, even in its most exceptional descriptions and cases, as considered in every major Tradition and in every real sense is just the beginning of Real Work, Real Life, and Real Play. It has been described by the very ones who have Awakened as purely the chemical/psychic Destiny of the common man, even through eternity. Awakening is simply the Bright responsibility of a Man or Woman *already* Enlightened, *already* "united" with God, *already* undeniably existing as the very process of Divine Evolution and eternal Expansion itself.

One who is Awake, in the spiritual sense, is expressing Light, is Rapture itself, ecstatic, blissful. Such a one is like a pulsating moment or event of Radiance, filling all corners and all directions with light, even unto the darkest place in all of the universes. Such a one is Love itself, present to shine on any and all who will recognize this benediction. And shining on all who won't recognize this benediction as a silent and profound encouragement towards recognition. Surrender to the Will of God, or Slavery to the Law in every moment, allows one to be or to exist as perfect sympathy to the Divine Process and to the Divine Essence, which is itself Light, Love,

Power, Glory, Compassion, and Mercy. Such a one loses personification (in the Real sense, not in the apparent sense) in bending to the needs of everyman, and even to the endless worlds of creation in every form. Even this concept is mindlessly unimaginable, even unthinkable to one who thinks or perceives from the posture or context or disposition of survival, separation from God, and the need to sustain this human form immortally. For one who does not see God as the Father and Source of all, including that one's very existence, any consideration of the Truth of Awakening is conceptually impossible.

Loving God, however, is quite different from, essentially distinct from, Awakened existence, function, and surrender even though it must arise from the context of Awakening. Loving God, which is pure Gift, literally the *only* Grace, is a condition (not a gesture, a posture, or a positioned or positional meditation) in which the entire Radiance or expression of universal Light, impersonally breathed in every moment and to everyone/everything, is limited to one channel or beam of direction which is God in Personal Form.

Being Awake and therefore surrendered to the Law, Sacrificed to the Great Process of Divine Evolution, is being a reflector of God, bathing all beings in this outward reflection or radiance. Loving God is reflecting God only back to Himself. Loving God is a reflection of God to God. Being Awake is a reflection of God's Reality to reality. Loving God is being turned only in the direction of God, melting in every moment in the heat and passion of one's Love *for* God, in all God's glory and beauty, in His completely Whimsical Being. Being Love, on the other hand, which is the condition of Enlightenment, is expressing this Love outward *as* God with outwardly no distinction as to the object of this reflection and with no reflection *of* God. This significance may sound ridiculous, but it is absolutely and profoundly meaningful for human beings (and only slightly less so for other forms of life, particularly other-earthly forms).

God's Will is essentially mechanical in the view that the Process is impersonal, evolutionary, and in some other-than-three-dimensional way predictable. Prophecy, particularly of the type by spiritual Masters rather than the trashy psychic type, is a function of the predictability of the Process. Even the great leaps in manifest existence (as from fish to amphibian, amphibian to bird, etc.) are predictable from the proper vantage point. So being That, one moves, or more literally and actually sustains and allows the created worlds to maintain their continual expression as Evolutionary Divine Creation and Activity. This *is* Love, beaming to the ends and the heart of existence itself but is not Love expressing itself *to* any aspect of this existence — it couldn't be by definition or by function. The Will of God lights the vision of the observer (both the self-observer and the "other"). All are served by this Process equally. All, not just human beings, but All of creation, animate and inanimate, are moved by this Process in direct relationship to the individual capacity of surrender, vulnerability, faith, and understanding or in other words by the degree of responsibility for Enlightenment. A quartz crystal is responsible for Enlightenment but can do nothing about it. A man can be or may not be responsible for Enlightenment and can only do something about it before surrendering. After, it is only God's Will. All are bathed by Love without distinction, in relationship to Awakening.

The Whim of God is above, or rather transcends the Law itself. Only the Lover can surrender to This. The Love of God pierces the Lover with the slavery of ultimate *personal* service which doesn't necessarily give the observer vision but blinds the observer in its brilliant glory. The self-observer is blinded by only the vision of God's personal aspects and the "other" is blinded by the unimaginable light of the Lover. In relationship to the Awakened one, one is bathed in outpouring Light and Love. In relationship to the Lover of God, one is awed and humbled by the beauty of Love in expression. In relationship to the Awakened one, one is speechlessly struck

with the ecstatic communication of Love. In relationship to the Lover of God, one is freed to speak endlessly about the Glory of the vision of Love in its fullest expression.

The perfection of the *human being* is perfection in human terms. This is not a limitation of form but the perfect form of form. The traditions tend to suggest or imply that the transcendence of all form is the ultimate existence or state of being. But the Truth of existence itself, is nondual Reality. There is only God, only this Great Process of Divine Evolution. This is a given fact of all existence, regardless of form, or not-form. There is no distinction between a human being, a frog, a platypus, a lump of iron ore and a Gryswilviz in terms of the essential fact that there is only God. Non-dual Realization, or the Awakening to the truth of already Present and eternally True Enlightenment (retroactive of course to the Beginning, whenever the heck that was) or the complete assumption by the Will of God is perfect in Essence, but not in form! This Realization, this Awakening, is the Male aspect of the polarity of all things. It is the realization and ultimate fulfillment of the Yang or masculine nature of the being. But it is not the ultimate fulfillment of the Yin, or feminine aspect, which is indicated by all form, all manifestation, all turning *to,* as differentiated from all radiating out *as.*

The ultimate perfection of the feminine aspect is the perfection of each form *as* the real potential of *that* particular form. So this ultimate aspect of masculinity is the same for all forms, complete existence *as* God and *as* the Essence of the Great Process of Divine Evolution. And the ultimate aspect of femininity is different for each and every form. Loving God, or being completely eclipsed by *Loving,* blinded by the light of the Beloved is the ultimate possibility of a human being, of a human form. The Divine Destiny of all human beings is to fulfill the Law in every moment which eventually takes place in any case (even if it takes a million lifetimes) because this is *already* essentially true of every one. The Human Destiny, which is the playing out of the feminine

aspect of Manifest Divinity, is to fulfill all Karmic implications in any given lifetime and to "make peace" with the fact of duality. And Loving God, which is not a Destiny, but pure Gift, and the *only* Grace, is the ultimate possibility, but not a probability or a fate. Loving God is to be caressed in ecstatic joy with every *Whim* of the Beloved. It is to fulfill the Law by nature or by Momentum of a Divine sort, and to delight in supersensory Rapture in God's own transcendence of the Law in His Play through Whim.

Loving God is pure Gift. It is the *only* Grace. Await with tears for they will flow unceasingly and in wonder when the Beloved shows His form.

Even though the Will of God or the Great Process of Divine Evolution is in a sense predictable and mappable, and even though this profound existence moves in a given direction, even so, all of the exact manifestations, every particular form in its own right is a random element of arising creation. The Great Process of Divine Evolution, the Will of God, that is intelligent and foreseeable, even predictable, is Matrix or Context in which events, objects, and all specific forms arise as content.

The Whim of God plays in the midst of creation directly in line with that type or form of creation. God's Whim for an extraterrestrial would not manifest for a human being. But God's Will might, which is the reason why there are some "strange" and other-worldly events arising on Earth all the time.

Mankind itself is a random form, a random event. We are random creatures. Mankind is not necessary. No aspect of creation is necessary. No single form is crucial to any overall "plan" of the Great Process of Divine Evolution. Only the Matrix of creation itself, only the Context of the Will of God, or already present Divinity or Divine Essence is "necessary." Still, because any specific form exists, even though it is by its very existence random, it inherently has an ultimate possibility for that specific type, as well as its various Destinies. There

is an ultimate human possibility, along with both the human and Divine Destinies for each being and for Mankind itself. The complete randomness and the total unnecessariness of humankind does not obviate the ultimate possibility of this particular type of creature. Of course because we have randomly arisen (we have not been randomly "created" in an intentional, intelligent way — that is, not in a way that relates to human intelligence — no form of creation has been "created" as part of a plan, Divine or otherwise — and this does not conflict with the predictability of the Great Process of Divine Evolution), we can also randomly cease to arise! In that event, there will also cease to be a human possibility. But as long as we continue to exist, we may consider our ultimate possibility and in fact it is crucial that we do so.

The Divine Evolution of the Matrix or Context of existence, which is God's Will, moves in a Divinely intelligent spontaneous fashion, with creation continuing to randomly arise as infinite and eternal form within the context of the Will of God. But no specific form is planned. Only the Divine "direction" or Essential continuation in Evolutionary or Expansive terms is "planned."

The ultimate possibility of any human being is to Love God. The destiny of any human being, even of the entire Race of men, should we continue to live that long, is to *be* Love, to be responsible for the fact and nature of our already true Enlightenment. As we mature as a race and culture, we move to the surrender to God's will, which is already the fact of our existence, taken out of a temporal, spacial framework.

But Loving God is not our Destiny, it is our absolute possibility, which completely transcends the Law or the Will of our Destiny, human and Divine. The possibility of any form or content is always Whimsical and always totally free of the Will of Context or Matrix. Loving God is the *only* human event or possibility that transcends the Will of God and the Born and Divine Destinies of Man in Man's case. Loving God is purely Gift. It lifts man out of his destinies for

a lifetime but does not, cannot alter a man's destiny over eternal time. Loving God obscures man's destiny for a lifetime through the Rapture of the vision of the Beloved, but man's destiny goes on in its own Willful way in any event.

Gift is a delight, but nothing, not even God's Whim can alter the Great Process of Divine Evolution. God's Whim can Brighten one's view or vision to the point of such a one seeing only that Giver of Gift but the Process will always have its way nonetheless. Loving God does not have its "way." Loving God does not alter a man's existence but only Graces such a man with the ultimate possibility of the human Heart, mind, cells, and sight. Loving God is not simply a Blessing, a Benediction, but it is the *Only* Grace.

The *only* Grace is Loving God. The word Grace is commonly used to connote a certain positive influence, or event that takes one out of the ordinary or mundane focus, a "gift" from God. That is the case in some way out consideration, but in the way Grace is usually, even traditionally seen, it is simply nonsense. There is only one Grace, and that is Loving God. All of the other events or circumstances that are called "Graceful" are simply the natural destiny of the profound recognition of, or momentary sympathy with, the Great Process of Divine Evolution. When one for a moment truly follows or surrenders to the Law of Sacrifice, the One True Law, such a one *naturally* manifests or finds arising a free and glorious Presence that is called God and that provides circumstances that seem to be "just what the doctor ordered." But that is not Grace! That Presence *is* Divine, for sure, but not Graceful, only Natural and Lawful and already destined and ordinary, already True and Real. The *only* Grace is Loving God.

There is a tendency to associate the "giving" of Grace or the making available of Grace with the Divinely Influential presence of the spiritual Master, the Enlightened one. So students will commonly say that he (the Master) bestowed Grace, or his Grace was offered freely and such references to the dispensation of Grace as if it were a quantitative form of

energy (like gravy at Thanksgiving dinner, and they are even spelled with the same amount of letters, the first three being exactly the same!) that could be directed in some way ("Please pass the Grace, thank you"). But Grace is none of that (the pleasures of Thanksgiving dinners notwithstanding). It is the Gift of God and *only* Gift. God's *only* Gift is Loving, not being Love which is His manifest Destiny, His Essence, Being, Quality, Texture, Context. The *only* Grace, which is Gift, is *Loving* God. All of the certainly Holy and Sacred expressions of God's Essence, the Rapturous and Ecstatic experiences, the magnificent moments or periods of perfect Divine or enlightened clarity, or True Remembrance, and so on, are just the obvious results or effects of Right Alignment or surrender to the Law, or of perfect coincidence with or ultimate identification as, the Divine Itself. And this is "Just This." But it is not Graceful, being simply the natural inclination of the essential being to be true to the Great Process of Divine Evolution (unfoldment).

The circumstance of the arising of the Divine Person in the form and personification of the Godman does not dispense Grace as if it were some wonderful, magical, and all-curing medication for mankind's ills, or as if it were some potion that could occasionally, in specific circumstances alleviate man's burden for some short while as a promise of good things to come when he dies and goes to Heaven. That vision of Grace is only the foolish and hopeful childish demand for God to perform as humankind egotistically and self-absorptively wishes. The Divine Person in the form of the Godman offers a beneficient and ultimately Sanctified Divine Influence that is already healing through the obviation of sickness through knowing (rather than through the cure of a symptomatic response to any illness that is assumed as essentially real in and of itself), an ultimately transformative power through the literal Evolution (transfiguration in bodily terms) to Light as Essential Divine Existence, and a constant reminding factor of the reality of "Just This." But the *only* Grace is Loving God.

The Godman can not "give" that but can Love God if he is so Graced, though this is rarely the case, even for such Awakened teachers. Loving God can at best be communicated through Divine Implication, in such cases.

Grace, as pure Gift, this Loving God, is just as Graceful to the spiritual Master as to anyone. The Godman *is* that Great Process of Divine Evolution and exists *as* Love and Divine Influence yet this most profound and unimaginable existence does not include Loving God. Only God can Gift one with the Grace, the *only* Grace there is, of Loving God. The Godman is as incapable of "giving" Grace as he is of "doing" anything. He is That, but exists as that Divine Influence, not as some form of active dispenser of some imagined God-magic.

One must not mistake the natural expression of the Great Process of Divine Evolution; which may include extraordinary Blisses, mindless raptures, mystical visions, and supernatural miracles, all more than Heavenly compared to the mundane existence of the common man, or may simply be the Presence of free happiness and understanding, for Grace. The Process that is God, God's Essence, His Being is unimaginably rich, passionate, and even Transcendental. But that circumstance, that sympathy, surrender, presence, is still not Graceful, but only Destiny. The *only* Grace is Loving God.

This may be very dangerous business I'm telling you about, spiritually speaking that is. You had better be very cautious before you consider allowing yourself to be naturally and spontaneously surrendered to the non-dualistic Reality of things while your intelligent and conscious focus becomes Loving God. I mean, perhaps I am misleading you. Perhaps I am wrong, deluded, or even have succumbed to unenlightenment and am using this Loving God argument to "save my public neck" so to speak. Perhaps I never even was Awake and this whole business is a function of ego-panic! Perhaps I'm hoping you'll never "find me out."

Perhaps this Whim of which I speak is just the newest excuse of Ego to avoid the intense demand of Real Spiritual Work. What is this Whim, anyhow? What an absurd proposition this whole business is. Yes, I think you had better consider this very deeply before you give up the brilliant and insightful focus of non-dual consideration to be swallowed up in the absolutely hopeless possibility of Loving God. For *you* can understand, *you* can be surrendered, centered, full of God, Ecstatic. *You* can do Sadhana with intention, consciousness, and with all of *your* Will/will. But *you* cannot Love God of your Will/will. You can only Love God by His Whim, and purely through Gift. This is much too ridiculous a matter

for serious thought. Perhaps I am just crazy after all. Perhaps you had better seek sanity elsewhere.

In order to be even available to the reception of this Gift, of Loving God; in order to be part of the Lottery, one must first be totally surrendered to the Will of God. To be surrendered to the Whim of God, which Loving God is, requires the absorption in the Will of God, which is complete sympathy with the Law and Slavery to the Great Process of Divine Evolution. The Whim of God is so Wild, so a-Lawful, that only one who is first obedient to the Law completely can surrender to the possibility of a-Lawfulness. Life is either un-Lawful, which is the life of the common man, the life of suffering and separation from God, the life of illusion and belief, concept, the linearity, or one is Lawful, which is the life of total surrender to the Will of God, the life of Awakened Enlightenment. The Whim of God on the other hand is a-Lawful, which is impossibly demanding, impossibly, literally impossibly compromising. So one must have no personal or separative demands first, as the basic ground or matrix of one's being in order to be capable of a life of such impossibility. Otherwise Loving God would simply crack the personal one into inconceivable pieces of pain and anguish, separative pain and anguish, not the blissful pain and anguish of God's Will. One who is full of self, full of individual considerations and territorial imperatives, can only find the Whim of God to be false, illusory, ignorant man's im-

aginative or fearful creation, or even the "work of the Devil."
To one full of self, even the very thought of the Whim of
God in this radical way, is madness itself.

One who is full of independent sensation and moral
perspectives may imagine a-Lawfulness to be somehow
breaking the Law or being greater than the Law, and may
imagine this condition to be very powerful, superhuman,
even superdivine, and may imagine that to be sort of heroic,
but such an attitude will not save its owner from "dying like a
dog." Surrender to the Whim of God, Loving God, is not
breaking the Law, nor is it above the Law. It is simply not of
issue in relationship to the Law. And the Whim of God, in its
activity, is the *only* circumstance that is that. It is the *only*
Grace. That is what Grace is! All of the fanciful and
philosophical meandering of mankind's seeking only abuses
and bastardizes God's Whim, claiming its own petty whim to
be Divine. Such foolish, even deadly, poisonous behavior
and thought is only evidence and circumstance to recognize
that the only Truth is the Great Process of Divine Evolution.
Such blindness ideally offers the possibility of the clarity of
the only unitive thought, the surrender to the Will of God.

When one is not surrendered, not sympathetic to the Law
of Sacrifice, one is easily distracted by more and more
sophisticated forms of worldly play. Every distraction bends
one's vision, one's focus away from God or out of the fulfill-
ment of the Law, and towards the distraction, whatever it is.
Religion, in its contemporary circumstance is a perfect ex-
ample of this principle. One's view is split, one's mind is
undecided, multiple, unsure. The absorption in the Beloved,
the vision of one-pointedness that is Loving God, would
(hypothetically, of course, if such a case could possibly exist)
be poisoned by reenforcement of the isolated and multiple
self of distraction. Any movement towards the world,
towards the need to sustain survival of the transient self (the
mind/body complex arising in the specific form that it ap-
pears as in this lifetime) would be a movement away from the

image of God, as Beloved.

This argument is quite academic of course, for Loving God cannot be divided by otherness, but at the same time anyone not Awake, not living Enlightenment as it arises as the Great Process of Divine Evolution through surrender to the Will of God, which is sympathizing to this Great Process in totality, is subject to the aforementioned distractions or doubt or dividedness, not only in principle but in absolute certainty.

Multiplicity is only conceivable, even possible in the numerous and ever-glorious visions of the Face and Form of God the Beloved, that is True Multiplicity. The Lover of God will see every facet of the Beloved, every infinitesimal aspect in all their infinite ways. But divided attention between the world and its infinite forms and God's infinite forms in His bodily beauty is impossible. One either Loves God, or does not, even if one is surrendered to the Law. One surrendered to the Law, one Awake to Enlightened vision, may in fact see the world in infinitely beautiful ways but one who Loves God sees *only* God. And such a focus, such an absorbing, con-suming Vision is *only* a Gift. It is the *only* Grace.

The Way of this Work that I am here to communicate is the inherence in already incarnate Divine Essence, that fulfills the Law. I have come or rather have appeared here in this time and place in order to transmit the Awakened power and glory of God to devotees. My work is to make this profound and Holy surrender to the Will of God, this One Great Law, evident in the practice and ecstatic lives of students, devotees, and workers of God. The fulfillment of this Way is the complete sympathy with, to and as the Great Process of Divine Expansory Evolution.

This work is extraordinarily different, this life is extraordinarily sacred in its implications and in its profession of Truth and Light. One, everyone, must be converted to the Realization of God as moment to moment revelatory rapture and blissful communion with the nature and destiny of one's born existence. The fulfillment of the Law, in every instant eternally is what my friends and devotees are called to. Such is the Benediction of my Presence in their lives and in the manifest and unmanifest worlds. To fulfill the demand and expectation of this Way is to be Awake, alive, rich in the uncommon joy that is knowing God and moving only by His Will. That is the perfect capacity of all who "have ears to hear, have eyes to see." That is the ultimate potential of life at My Feet.

But there is a possibility that exists, even rarer, even unimaginable in its Majesty. It is only Gift. To Love God is the possibility that exists for all who have fulfilled the potential of this Way of Life and Teaching. For all who have surrendered the illusion of separate-self sense and existence, who have bowed in absolute devotion at the feet of the Lord in personal form, who have obeyed in response to the unspeakable and unfathomable Mercy of the Lord's Availability, there exists a possibility for Loving God. The surrender, devotion, and obedience that is evidence of the Willful assumption of the "individual" by the Great Process of Divine Evolution offers at least the ground in which the Gift of Loving God in all His Beloved Glory can be offered. This Loving God is pure Gift. It is not earned, never deserved, and only randomly bestowed by the pure Whim of God. This is the very Whim that the Lover of God is so captured by, obscured by, and made joyously a slave to. But even this Whim, though academically possible at any moment whatsoever, only recognizes first the perfect devotees from whom to choose the unlucky donee.

So one must fulfill this Way that I offer. One must live as the very ecstasy that is Divine Will and eternal expansion. One must serve God in every moment, *as* the very Process and Law itself. Then this possibility of Loving God becomes a viable expression of ultimate *human* concern. But Loving God is pure Gift. It is the *only* Grace. It is not destined, or necessary, or even desirable. It only illumines the knowable worlds with its example but does not serve the Will of God the furtherance of the Divine Process in the least. It is ac- 'y valueless in Divine terms. But in human terms, it is the ²st possibility, the peak, the only real acme of human ce. Loving God is not our destiny, but a Gift, a pure *only* Grace that blasts destiny into oblivion.

One must approach the spiritual Master with surrender as a way of life, devotion as the mood of relationship, and obedience as the content of this way of life in order to be availed of his offering, this Divine Influence. He has appeared randomly here, yet being here he may not be random. Once appearance, or manifestation (incarnation) has arisen in any way, that appearance or that arising must serve that particular focus. He offers the power and the circumstance in which one can be Godly. He offers the Body through which one can perfectly Realize and be responsible for what is already the case, Enlightenment as the essence and activity of being. He offers a place to live with devotees of this way, which ultimately assures the destined culmination of all births and deaths of any individual, which is the perfect sympathy to and activity as the Great Divine Process that is Evolutionary in nature and ecstatic in essence.

To serve the spiritual Master is to do what life is all about. To serve the spiritual Master is to be in right association to God. To Love the spiritual Master is not to Love God, but is to be God. To Love the spiritual Master truly is to exist as the Law. To Love the spiritual Master completely is to fulfill human and Divine destiny, to be surrendered to, a Slave to the Will of God.

Still, this is ordinary in a Divine and Godly sort of way.

This, everyone's destiny, is natural to the essence of human incarnation. This way, and the promise of this way is only Holy in the way man was meant, created to be Holy. It is sacred in an obvious relationship to the natural and eventual sanctity of all born Men. He has appeared randomly, yet now existing in this moment as this appearance he fulfills this appearance's only possible function which is the re-enlivening and re-membering of God, the only and essential existence and nature of things already, amongst those who have forgotten, both in the human race and in other realms and planes of manifestation. Having appeared and having recognized the obvious futility of the conventional search for fulfillment, the clear illusion of the organic drive to sustain survival and immortality in the face of our undeniably mortal coils, and the emptiness of the world of any true religious or spiritual culture, he now serves the work of the Great Process of Divine Evolution which is the demand for every Man to cease the mundane and hopeless attempt of seeking for attainment through conventional forms or ideas of immortality and rather to Realize ultimate immortality through the Realization of ultimate mortality, and to live a life of True Religion and Real Spiritual Culture which embodies surrender as the context of such a life, devotion as the mood, and obedience as the form or content, all in direct and unmediated relationship to God as Light and Existence.

He serves this Process and this Understanding by virtue of his own existence as this very Process itself. This is not the "good news" that he brings to the world in these troubled times though, even in spite of its Enlightened message. The "good news" that he brings to Man, the Gospel that he establishes is the Gospel of Gift. The "news" of already present and eternally living Enlightenment has always been available in the natural understanding of all who will submit to the truth and obvious nature of their existence. It is not "good news" but rather the known destiny of all men.

He brings the "good news" of *Human* possibility, not

simply the message of destiny. He brings the Gospel of Loving God. Loving God is Gift. The *only* Grace is Loving God. The spiritual Master's presence here, as Godman, is not a Gift or a Grace. His work is his work. He cannot be other than "Just This." It is special, even extraordinary in the sense that the Divine Influence made manifest in the world is always special and extraordinary but still his presence can only be That, there is no other alternative.

The Gospel that he presents, however, is his specific contribution to Mankind and to the Spiritual culture of the human race. The "good news" that he brings is that once one Realizes through Revelatory knowledge what one already is and always has been, then it is possible to be Gifted with the *only* Grace, Loving God, before death in human terms.

The spiritual Master's presence here is no contribution to the world. Godmen, Godwomen, are always appearing randomly and arising when the need is great. There have always been Enlightened teachers in human time. The spiritual Master's contribution to True *Human* Culture is the Gospel that the *only* Grace is Loving God. That as human beings we *must* be submitted to the Law and that we *may* be submitted to the delight and majesty that is God's Whimsical shower of Grace, His *only* Grace, Loving Him. This is the "good news" of the Gospel that he pronounces.

The great message that I have to communicate is that it *is* possible to Love God. That may seem puerile, considering the vast quantity of published and oral "teaching" about love these days but it isn't as obvious as it may sound. Actually, from the enlightened point of view, which is the only point of view from which one can be available for this Gift anyhow, the knowledge that it *is* possible to Love God (not just that it is possible to Love, which is itself the nature of the enlightened state of consciousness) is profoundly awesome.

To the common "new age" man or woman it might seem that Loving God is even a common affair, but to the piercing vision of a man who Sees, all of this business that passes for love or loving God is just so much monkey business. It is all trash (though a much better grade of trash, "arty" trash, than war, violence, and the inhumanity that is so common in this age.) Loving God is not a genitalia affair. It is not a matter of some touchy-feely massage jazz or a bath naked in a hot tub with members of all sexes. Loving God is so exclusively encompassing that it completely obscures the new age philosophies and their attempt at defining reality. One doesn't even think to consider "self-improvement" in any sense (as contrasted with the one who is surrendered to the Will of God, who is objectively critical, in a compassionate way, of the self-absorptive and isolationist demands of all

self-improvement courses and schools).

Truly, when the Way makes itself known to anyone in a real sense, it becomes obvious that Love is not the kind of relationship that the word is always used in conjunction with in conventional and unconventional terms. It becomes clear that to be Love is the only permanent situation that pierces the dilemma of self-centeredness and separative drives that cannot support or condone Love in its true sense. There may be moments of extraordinary, even supernatural associations between mates, friends, parent and child, that pierce the ordinary mood and posture of only egoic existence but such moments are obscured by the clash of tendencies or premature ejaculation or unwashed or unironed clothing. Such moments are merely a gesture towards the truth, towards surrender. But they arise from the context of separation and so are doomed to quick extinction and fantastic interpretation and misinformation. One who begins to See in a Divine way recognizes that to Love is to *be* Love, to be fulfilling the Law in every moment, to be completely identified with/as the Great Process of Divine Evolution. Such a one recognizes the possibility of Loving because the world takes on a quite different "glow" or aura than it does to the view of the seeker. The world ceases to threaten survival. One's friends, parents, children, and lover or mate cease to be the source of fear and cultic territorial battles. For such a one, loving becomes quite possible, even true. Yet also to such a one, God is revealed as such Glory, such Mercy, and such Holy Majesty, that to even consider the possibility of Loving God is a miraculous affair and is unreservedly good news!

The common man has so limited a perspective, guarded by jealousies, prejudices, and crystallized world views, that even that consideration of God at all is non-existent in any serious fashion. To such an unenlightened attitude, to suggest Loving God appears to be as ludicrous as flying or as common and acceptable as the availability of pornography these days (in its printed and living forms). Such a one is not amazed, not

grateful, not reverential, when confronted with the miracle of the actual *human* possibility of Loving God. Such a one has no capacity to appreciate the Sacred, the Blessed, the Profound. To such a man, the only "good news" is a shower, an expensive meal, and the fact that his neighbor is no longer earning more than he. Even his children do not inspire awe in him.

But to the man who is a Slave to the Will of God, the delight of the play of the universe, the bliss of the essence of God, and the Process of Divine Evolution as known to be his very ground of existence and the matrix of his actual manifestation, all allow the possibility for the knowledge that he may be Gifted with Loving God. To the common man Grace is falling asleep during the Priest's sermon on Sunday but to the Slave to the Will of God, it can now be told that the *only* Grace is Loving God, and slavery to His Whim, not only to His Will. And it can now be told that it *is* possible, not simply academic or hopefully imaginable. Such a one will rejoice at this Gospel that I proclaim. It *is* possible to be Graced. It *is* possible to be amazed and warmed by the Whim of God. One who doesn't Love God, when confronted with the Whim of God may be curious, confused, "unearthed," and can only be so, for the Whim of God is really Whimsical. It transcends the very Law that is God's actual Will in every moment and under all circumstances. The Whim of God not only demands but can only be responded to by slaves who are Lovers, mere servants will not sit still for such outrageous expectations. In the moment of God's Whim, only one who Loves God can still smile radiantly and with ease and light at this Whimsical Play. To be the Slave of the Will of God is itself easeful, and requires no effort of personal will or intention because every movement, all action itself is God's Will to move or act. Such a one is surrendered to God's effort, and every movement, every action is perfectly Lawful.

But God's "fancy," God's Whim, is profoundly and intimately personal. It has no relationship whatsoever to the

Great Process of Divine Evolution, it is a-Lawful. It does not interfere with the Process, yet it has no relationship to it at all. Such a personal expression of God, without consideration to the Law, which is itself the totality of the Nature of God and the complete essence of His momentum, though it may fall within the Law, and it may not, requires, demands a slave to this Whim. Only a Lover can maintain equanimity in the face of Whimsy, especially God's! Only a Lover can enjoy the Beloved in the midst of bouts of this Beloved's Fancy. This is the "good news" then: that it *is* possible to Love God and that although the *only* Grace is Loving God, the *only* possibility pure Gift, it can be given to the greatest warrior of God and to the meekest beggar of God equally, randomly. It is truly possible (at God's Whim, of course)!

The possibility of Loving God is only the Graceful possibility, the *only* Graceful possibility. It is not destiny, human or Divine. The possibility of receiving Gift does not preclude the need to surrender to the Will of God as evidenced by the Great Process of Divine Evolution. The Presence of the Godman, and the paradox of his activity, his madness, his benign compassion, is the necessary help for this submission or surrender to the Will of God. That radical teaching of already present Enlightenment, radical in every age in which it has publicly appeared, is man's recourse to God and the Law. The spiritual Master, the Godman must work in the way he works, notwithstanding the "good news" that it *is* possible to Love God.

The understanding that the *only* Grace is Loving God, through reception of Gift, simply gives one a restless yet anticipatory vision of ultimate *human* possibility. It does not lessen the need for surrender, or obviate the appropriate arising of devotion and obedience. One must be purified in any case! One must enter the Fire of God's Will and be tempered as His Slave. One must awake and Realize the nature of this already present Enlightenment. One must appreciate through organic and non-organic rapture and relationship to all of God's "creations" the absolute nature and demand of the Law. The Law is undeniable, it is everyman's destiny. This is

in no way altered by the possibility, even by the example of Loving God. Loving God is Gift. It is not to be sought or expected as a child expects a bike on Christmas or on his birthday. But its true existence in this world may be considered with the Holy awe and respect of a man faced not with his destiny but with his ultimate possibility as a *human* being.

In any case the Great Process of Divine Evolution always has its Way and men are all purified, burnished in this Fire in any event. Loving God, the ultimate *human* possibility dissolves when the *human* vehicle dissolves. One who is surrendered to the Will of God, the true devotee, may not be *human* again! Loving God is a Gift, the *only* Grace, for a lifetime, a *human* lifetime. It dissolves in the force and effortless Great Process as Divine Evolution has *its* way after the human vehicle "dies." The Lover of God manifests the most amazing possibility, the ultimate possibility through Love of the Personal Beloved, but such a one does not cease to be moved, as are all beings, even God, by the Great Process of Divine Evolution. This message is the message of Lee Lozowick in this form of random appearance. God has offered the Godman. God offers the Fire of His purification through the Divine Influence of those submitted, surrendered to His Will. But what I offer is the Word that it *is* possible, and thoroughly Graceful, *only* Graceful, to Love God.

Although many of the traditional descriptions of Lovers of God imply states of absorption or detached consciousness, Loving God is not a matter of being blind to the realities of dualistic manifest life. Loving God is a conscious process, the consciousness simply being quite one pointed, or focused. A Lover of God isn't "simple" or "dense" or "naive" as one might refer to a "country bumpkin." Such a one has as piercing a vision of the nature of things as anyone who is responsible for his/her Enlightenment. Loving God is a matter of absolute attention, in all forms, to God the Beloved but this does not mean that conventional processes such as eating, sleeping, relating to others in social ways, and so on dissolve, although they might in random cases. These normal functions are done naturally and easefully while Loving God.

A Lover of God *may* forget to eat, may forget to sleep, may be so attentive to God that normal social conventions appear to be disrupted or ignored, but the essential nature of a Lover of God's life is such basic all-pervasive enjoyment of the Divine Object, the Personal God as Beloved, that all other objects (like sleeping, eating, and social conventions) simply cease to have value.

God the Beloved is all valuable to the point that everything else, which organically or non-dualistically *is* the Great Process of Divine Evolution in essence, *is* the Body and Soul of

God, nevertheless not personifying the Beloved in *human* terms, ceases to attract or be necessary. The maintenance of "ordinary" or socially accepted behavior is not the motivation anymore, for there ceases to be any investment in pride, the need to "keep up with the Joneses," the need to present a certain face to the world and so on.

When a Lover of God eats, defecates, even breathes, it is not because these processes are necessary but simply because they spontaneously arise without distracting the Lover from the Beloved. The only process that distracts a Lover of God is Love for God! And that process distracts the Lover totally. Sometimes the Lover of God is "distracted to distraction," in which case the outward form may appear wild or mad or even catatonic and at other times the distraction that is the process of Loving is completely absorptive without fundamentally affecting the already Enlightened behavior that was naturally and spontaneously present before Gift was bestowed.

Although the Lover of God may subscribe to various forms of activity and behavior, he remains completely unmoved by those forms, untouched by them, being moved only by the process of Loving God. He may appear mad, but he should never be mistaken for a misguided fool. He is the *only* Graced human being. When one considers what it means to Love God, such a one would gladly allow the conventional forms of receiving the "blessings" of society to fall away in the face of receiving the possibility of Gift, the *only* Grace there is. Grace is the replacement of the madness of both the world and nonduality by the Madness of Loving God. And such Madness is truly Graceful!

The nature of God's Will is obviously a Positive, Divinely Influential process. The Will of God may effect certain dramatic events or circumstances that are the result of purification of resistances and dissolution of obstructions to the perfect sympathy to and manifestation or movement as the Great Process of Divine Evolution. But essentially, or primarily, the Will of God is recognized to be a thoroughly positive force over time and from the proper disposition or view. The Will of God can be instinctually felt to be "right" over and against various forms of manifested activity that feel somehow out of place, or not quite appropriate. This positive feeling has traditionally been viewed in personal, impersonal, natural, religious, philosophic, even scientific ways, labeled by various partial or misguided though sincere interpretations as soul-growth, self-awareness growth, metaphysical striving for superconscious states, and in all goal-oriented or achievement disposed methodologies as the creative power of spirit or God or oversoul and so on. Even though all of these ideas are partial or somehow missing the actual point, they are still relatively positive or salvatory in their message, and in relative terms actually do perform growth or awareness functions that are Karmicly "good" or healthy. They are not the point but they are at least more life-positive than the mad self-destructive negativity that is so

prevalent these days. The Will of God, in its true positivity, has been surrendered to or Realized by many individuals, Teachers, Saints, and Devotees for all time.

The Whim of God, also being evident in its effect, both in natural and human terms and events, has been traditionally viewed as devilish or evil. The Whim of God is a profoundly misunderstood aspect of the very real existence of the Divine itself. The Whim of God, traditionally and most prevalently in cultures that have become empty shells or dead forms of once living spiritual expressions (for example the contemporary state of most Christian churches and organizations which have almost entirely forgotten, or lost completely the real essence of the life of Jesus and the culture of the early, 1st and 2nd century Christians or practitioners — but this is commonly true of almost every artifice that has arisen around the myth of the true Godman) has been thought to be the "work of the Devil" or at best a cosmic accident, usually of quite unfortunate stature. The Whim of God is universally seen in a life-negative or in an ignorant framework.

The Godman is often seen or criticized during his lifetime as being mad, crazy, insane, or simply as being a deluded and mindless fool. He is frequently persecuted, and often slain, as in the obvious cases of Jesus, and so many of the early Sufis and the early Sikhs. But the Lover of God is merely looked upon with pity, as one who is unfortunate, confounded, or hypnotized. The Crazy Wise man is considered to be a shame to his family and a disgrace to society and a failure of the educational system, but the Lover of God is only considered to be a shame to himself.

The faulty vision of the *absolute* possibility of God, beyond even the infinite capacity for probability in terms of manifestation and creation, has escaped the realization of the culture of the common man as well as that of the "religious" man. The Whim of God is said to be "work of the Devil" so commonly because it is devilish! The Whim of God is devilish (not Devilish) in the same way a child has a devilish

look in his eye when he is about to do something completely whimsical! The Whim of God transcends the Law, it is a-Lawful, even though this Law is the absolute demand, the highest demand, the *only* true demand of all manifest existence. The Law of Sacrifice is everything's and everyone's destiny. The Law of Sacrifice *is* the essential nature and activity of all life, conscious and otherwise. The Law is *THE LAW.* And the Whim of God transcends this all-inclusive, infinite, untranscendable Law. That is why the Whim of God is considered "devilish."

The mind of man — and I refer to man, for certainly no other form of earthly creature considers the Whim of God to be devilish, or anything else exclusively either for that matter — is designed or rather has learned to function in a purely logical (even illogic has a kind of Zen logic to it, no?) way and in a way fearful of punishment for breaking the law, or at least in a way that seeks attention and recognition for breaking the law (Law). In either case the transcendence of the Law, or a-Lawfulness, in its implications shatters the world of the common man. So he calls this shattering the "Devil's work" so as not to admit to his suffering and his separative ache.

But I proclaim the truth of the devilish business. It is the Whim of God and is only for the Lover's delight and benefit. The Beloved is revealed in the Lover's slavery to the Beloved's Whim. This is definitely not to indicate or assume that all things considered evil or of the Devil are just the Whim of God for man is so deluded he even attacks God's Benediction without surcease. Certainly Jesus was not God's Whim, nor evil, yet he was considered such, even Devilish, and destroyed by the common man. This Whim of God, rarer than the rarest beauty, does arise randomly. And it is this Whim, Divine and Majestic, that troubles the mind of conventionality, and even the mind of seeming religious and spiritual convictions. But to the Lover of God, to the slave to the Beloved's vision and activity, it is only Whimsical and

magical and a great delight.

The Lover of God is the recipient of the *only* Grace there is, the one true and only Gift. Such is God's glory that even profoundly realized individuals are not Graced, only His Lovers.

It must be clear, or rather I would have it understood that I am no example of Loving God. I do not Love God, I have not been the recipient of Gift, I am not Graced. It must be clear that one cannot come to see me, as one goes to Ripley's Believe It or Not museums, in order to see the thing itself, in the flesh! Lovers of God do not "teach" about Loving God. They exist solely viewing the Beloved. Their sight is quite singular. Lovers of God do not see God in everything as a Pantheist might or as a nondualist might. At the closest state to this they might allow all things to *remind* them of God the Personal Beloved. But they never mistake a cloud or an ice box (refrigerator) for the *One* Himself. Never. So I am not a Lover of God. This must be clear. I do not attempt to mislead you to think I am That. I am a pauper, a beggar, a miserable excuse for the Lord's Divine Representative. Nevertheless, for what reason I cannot imagine, I do provide a certain Divine Influence, a certain Sacred communication, a certain profound and Holy Remembrance. I do offer a certain opportunity, I do make a certain possibility, even probability, available. God has assumed this one, in the sense that he has been surrendered to the Will of God and has become responsible in a real way for his participation in and personification as the Great Process of Divine Evolution. This one exists as the available Divine Person, God only knows why. This one

exists as the form of God as Guru, Godman, spiritual Master, and offers an Influence that is Transcendental, transformative, and transfiguring. But he does not Love God. He has not been Gifted, he has only been Sacrificed through surrender and Revelatory Rapture to the Slavery of and to this Great Process of Divine Influence. And too, the surrendering in every moment to the Glorious Will of God has given this one the blessed opportunity to *know* many things. This one has seen in Truth the Nature and Magnificence of the Freedom of God in Whim and in His Personal Whimsy. This one can offer the Enlightened Truth *about* Loving God through his Slavery to the Will of God which is the Great Process of Divine Evolution. I can tell you with Divinely Influential inspiration that Loving God is Gift and is the *only* Grace there is.

I do not Love God, but I may communicate this to you: the *only* Grace is Loving God and I have known and seen the Truth of Whim and that surrendering to the Whim of God is the manifest and tangible effect of Loving God and is the Gracious and always unnecessary Gift. All men called to Awaken in the truth of their already present Enlightenment are revealed in their Slavery to the Will of God. But only those who Love God are slaves to His Whim.

I rest in awe of that Whim, radiant from my Slavery to His Will, profound in the energetic Divine Influence that I so readily and directly communicate, full of the Bliss of Enlightenment and the demand of the Law and the relationship to Devotees, but un-Loving and blind to God the Beloved. He, the Beloved, is buried in the Revelation of God's Will and omnipotence, but unvisible to this pauper who ecstatically tells the world that the *only* Grace is Loving God.

I can say absolutely that this Gift is available to one who is randomly chosen by God as His donee, but in order to be available to being a slave to His outrageous and Transcendental Whim one must first surrender to His Will and be assumed by the Destiny of the Great Process of Divine Evolution. One

must take my offering, bow to my paradoxical Presence in this world, and wait in happy service to God for the vision of His beauty in the form and image of the Beloved. To Love God is His Gift, His *only* Grace. To serve the Law in every moment, to be eaten and used by the Great Process of Divine Evolution is simply the Work He has eternally spoken and ever presently speaks. His demand is to Wake up and fulfill the Law, serve His Will. His Gift is to Love Him beyond all distraction, a slave to His Whim.

Non-dualistic life, or rather the submission to non-dualistic principle is True, but demandingly foreign or alien to the fact of human life in this dimension. It is true that to be a Slave to the Will of God, to be existent as the Great Process of Divine Evolution, is actually non-dualistic in its activity and essence. On the other hand, the philosophy of non-dualism or the attempt to be non-dualistic in mind, body, or emotions is too "pat," too easy, too seductive in its implications, all the while being practically impossible on a practicing level. Non-dualism is very tempting, secure, free of pain in its promise, yet it is also free of the very humanism that is inherent in the fact of the existence of humanity itself!

Non-dualism is not un-true of Loving God, that is, Loving God is certainly dualistic in its expression and its experience but is not non-dualistic in Essence, how could it be? Yet at the same time Loving God is not detached from or does not obscure our humanness either. Loving God, which blinds the Lover to all but the Beloved, nonetheless does not obscure the reality of human life on Earth, as do so many of the Yogic states of absorption in the "Self" and so on. Loving God is still full of the apparent contradictions or apparent illusory dualities of life, it is meaty, sweaty, full of glory and praise, full of suffering and blame. Life on Earth is not inherently beautiful or absolutely free of negativity and pain, even

Enlightened life on Earth. Blissfulness is a function of being assumed by the Will of God, not a matter of things all going the way we want them to go. Of course the possibility of Transcendence is true of humanity also, but non-duality, unmoving and non-transitory, is a condition or space of direct limitation and exclusiveness, even though it is indicative of the highest Realization possible or the most profound Enlightenment possible. The truth of the matter is that "all things are transitory, including *non-dual* Enlightenment." When this case is not true of one, such a student actually assumes the limitation of the Pratekyabuddhas, having achieved Enlightenment for themselves but not returning to ordinary service or life for others even though they might well be still offering certain extraordinary services simply by virtue of the Teaching capacities that are inherently present through Enlightenment in any form.

Life here *is* suffering. Transcendence is the true state of Essence. Slavery to the Will of God is the true state of existence, or the optimum form of activity possible. But such states are not Earthly Real, only Divinely Real. I do not mean to indicate that surrender to the Will of God is ever common. That in itself is the effect and example of momentous Realizations and the strength of Sacred Traditions throughout history. But it is not the ultimate *human* experience, it is only *already* True of every being everywhere.

Loving God is not, *cannot* be attained, but it is not already True of anyone either. It is the only true Gift of God to Mankind. Loving God does not transcend the ordinary earthly circumstances but obscures the distraction in them, through the obsession with the Beloved's visage. What could be more truly indicative of *human* perfection in its surrender than being a slave to the Whim of God. For Earth, although Enlightenment is already true of all earthly beings, is also prey to the "free will" of Ego or Chief Feature which is absolutely whimsical in its direct disobedience to (unconsciousness of the Law is no excuse) and resistance to the

Great Process of Divine Evolution.

The ancient Vedic scriptures say that God grants Mukti or freedom to beings quite easily but that He grants Bhakti or Love, very selectively and rarely. Mukti or freedom frees one from the binds of Earthly or human concerns, while Bhakti or Love binds one to the Earthly or human expression of the Beloved's Whimsical possibility. And God is bound to the Lover and free of the Mukti. Loving God is the *only* Grace there is, and the possibility of Loving God is a Grace to God from Mankind as well as a Grace from God. Loving God is truly a human, earthly Grace. We do exist here, despite any number of philosophies that attempt to convince us that this is all a dream or an illusion. It is only our relationship to this that makes it illusory, not the fact of its existence. Loving God perfects it as it is. And we are already free of it all in any case! Death finally captures us all in the perfection of the "Divine Path of Growing Old."

Loving God demands the Wisdom of Awakening. To Love God requires a great and insightful clarity and a profound surrender to the Law as its ground or culture. One cannot Love God by choice or intention, from any position of even the slightest immaturity. The culture of one's life that encourages the Gift, this *only* Grace there is, to be conferred must be a mature culture of Enlightened Wisdom. One must be logically illogical in order to even glimpse most remotely the enigmatic truth of the Whim of God, let alone to be Graced with slavery to It.

The Whim of God is the ultimate enigma, the perfect paradox. Yet it is also a most tangible and understandable "characteristic." Such response of consideration must be and can only be found in the disposition of real Wisdom. Only a truly wise and Awakened individual could sustain the ridiculous foolishness that is indicative of a Lover of God. And this argument is the only thing that should be taken very seriously!

Lovers of God are great fools. They are preposterous and irresponsible fools! And they have been Gifted with such foolishness only because they have first exhibited the great sobriety of Divine Wisdom. A Lover of God need not be profoundly or highly educated, for Wisdom has to do with one's relationships to and understanding of and about things, not

with formal knowledge or data nor with the quantity or amount of accumulated information one has. The Awakened one may be illiterate in worldly terms, as many, many have been, yet truly Wise in Divine terms. To Love God is to have pierced Wisdom itself (as a necessary prerequisite) through the *only* Grace there is, the Great Gift that is Loving God the Beloved.

Loving God is being a Slave to His Whim. Being surrendered to God and in complete sympathy with the Law is being a Slave to His Will. Only a Lover or a Madman loses the analytical and rational poison that is obscured by the Sun of the Beloved's vision. To Love Whim as a rationalist loves "order" is the joy of a Lover of God. But even one surrendered to the Will of God may accept the Whim of God but cannot help but be confused, distracted, even annoyed by it. For God's Whim is so out of place! It doesn't fit into the Great Evolutionary pattern. It is out of the Matrix of the Divine Process. God's Whim is disturbing, there is no doubt about it. It is somehow unsettling. It isn't unsettling enough to allow one to "forget" God or Enlightenment but it is still somewhat unusual, somewhat disorienting, as if it doesn't belong where it so obviously is. The Whim of God is His ultimate personal action. God's Whim is His paradoxical Sacrifice to His personal Nature. It is just Whim! And it breaks out of the absolute discipline of His Will. It is exceptional. And the Gift that Graces the Lover, making a slave to the Whim of God, is the *only* Grace there is. It requires absolute Wisdom to become such a fool.

The fools of God are not fools because they have not the intelligence to "make something of themselves" as the world is always telling them, along with so many well-meaning and concerned friends. They are fools because they have reached the peak of intelligence, the peak of Wisdom and have "made as much of themselves" as can be made. They have surrendered to God's Will and become His teachers, His messengers, His prophets, and ultimately through His *only*

Grace, His fools and His Lovers.

This is not destiny I tell you about, it is to wait endlessly for His Gift. And only after you have surrendered into His Great Process of Divine Evolution, becoming "Just This" in every inconceivable moment, fulfilling Destiny of all sorts and possibilities, is it possible to Love God, but definitely not probable. First realize non-duality as your very essence, as the being and movement of God and in so doing be enraptured in Real Wisdom and Sanctity. Lose your "self" in the self of all, God's Great Process of Divine Evolution. Then be captured by the Gift of God in the offering of Himself as Beloved and become *human* at last (until you"die," at which time you cease to be human and so maintain the enlightened disposition wherever you may be but cease to need to exhibit the human quality of Loving God, or rather cease to be *able* to, which dies along with everything else "human").

Be captured by God, captivated by His Blissful and Personal Form, through the *only* Grace there is, this Gift of Loving God as the Beloved. Since there is nothing you can do to earn or demand this Gift, only prepare by assuming the already present and ever true condition of Enlightenment that is your distinction in the Great Process of Divine Evolution. Know the Truth of this, and serve, very much like Krishna told Arjuna in the *Bhagavad Gita*, "Surrender to Me, Remember Me, and fight." Don't wait for the Gift. Do what God Wills and *remember* the *only* Grace there is. Remember from Wisdom. Discourage sloth and dull-mindedness in yourself and others. Be bright, alert, and Wise. Remember God and surrender to and serve His Will. "Remember Me and fight."

Enlightenment is already true of all life. There is nothing to be attained, this is quite accurate. Why then do so many seekers of all types, bright, strong, healthy, even radiantly so to some degree, intelligent and insightful, even brilliant to some degrees, gentle, understanding, centered, even compassionate to some degree, seem so empty of true Enlightenment, despite their obvious "attainments"? Why do so many surely "developed" individuals continue to suffer and feel acutely their separation from God? Why is this so even though Enlightenment is *already* true of all of them?

Awakening, which is the Revelatory assumption of obligation for this true Enlightenment, and the surrender in body, mind, and spirit unto the Great Process of Divine Evolution, is not "given" as some sort of merit or reward by some "otherly" or fatherly God who stands outside of this world and of humanity judging the appropriateness of each individual's response to religion and doles out "awakenings" like candy or new titles on the human corporate door. Yet truly, Awakening must be *earned*. No simply extraordinary manifestation of body, mind, or emotion, is in itself the prerequisite necessary for Awakening. One must *earn* Awakening (even though it *cannot* be attained) through tapas, or the Real Heat of spiritual practices or Sadhana. One must submit to the Fire of God's Divine Influence, predominantly and most

availably offered through the form of the Godman and in the Presence of His Influence which essentially includes the good company of His devotees and the Holy site(s) of His Ashram and Sacred places of Glorification or Majesty. One must *earn* Awakening through submission and slavery to God's Will and through the dissolution of the illusory separate self through the piercing of the cramp of mortal survival beliefs and personal self-reference in the self-absorptive and obsessional mood of exclusivism and isolationism.

At first one must submit to the disciplines outlined and suggested by the Godman and one must do so in a very intentional and active, even enthusiastic way. One must simply follow directions! But even this is actually quite a major task for almost everyone. Even highly disciplined people by nature find it almost impossible, in a literal sense, to follow the Godman's suggested guidelines of right living. So one must earn one's awakening to that already present Enlightenment, beginning with the active participation in a process that aligns behavior to the form that the body/mind/spirit of anyone is naturally inclined to when surrendered to the Will of God, and living the Law in every moment. As this discipline is lived and experienced and surrendered into, one will begin to realize that more and more of the movement to do this discipline, to live such a life of right activity and prayerful functioning for/as God, will arise spontaneously and completely effortlessly. Life will become a natural turning to Divine activity instead of intentional utilization of structure or technique or discipline in order to achieve certain goals.

Once this process is clearly established, such a student may begin to recognize the same inherent reactivity that was present in relationship to this bodily discipline (e.g. to diet, exercise, meditation, and service or right livelihood) becoming apparently active on the more subtle levels of relationship. So then the next participation in this *Tapas* is to follow the same principle as the one followed in the grosser disciplines of the

body/mind in all areas of more subtle (less dense) energy such as in one's emotional considerations. So the active and honest and lucid interaction with or work on the areas of direct resistance and reactivity to surrender to God, on the areas that most substantially and ardently support and encourage the continuation of the life of suffering and separation from God, the life of illusion and delusion, which (this active work on) leads to the necessary heat required to fire or temper the devotee in the brilliant furnace of God, must be engaged with sincerity, enthusiasm, vigor, and vulnerability or openness to the transformative power of Divine Influence, essentially present in the body and life space of the Godman.

Awakening is earned, it is not freely given! And the process is not only profound, enlivening, and ecstatic but also hard, immeasurably hard, requiring great strength, patience, and perseverance. And it is the only life that is worth living. Spiritual life is the only real alternative to all forms of seeking, suffering, and myth. It is Just This. It is the *only* life to live. It is, despite the great intensity with which true Godlife is always presented, inherently joyous, pleasurable, and celebratory.

Loving God cannot be earned, and has nothing to do with this kind of "heat" or tapas. Loving God is purely Gift or Grace. Loving God requires the culture of Enlightenment as its ground or matrix, but no "enlightened tapas" of any sort "earns" Loving God. It is the *only* Gift of God or the *only* Grace there is. One must be "awake" in order to be available to this Gift, which itself requires great work to "earn" and to maintain but the Gift of Loving God is offered freely as the *only* Grace there is. Any form of Enlightened life, disciplined or lazy, sane or wildly lunatic, may receive this Gift. Loving God is a Free offering. It requires nothing but consumes its recipient. Living God, or being a Slave to the Will of God, surrendered to the Law and active as the Great Process of Divine Evolution, is a very "busy" and infinitely responsible activity. Living God requires great responses, great gestures,

great surrender. It does not allow one to choose to respond, gesture, or surrender but requires these forms of relationship by the consuming nature of the demand of this Great Process of Divine Evolution.

Loving God is free of all of that. Loving God is *not* responsible to or for the Law or the Great Process. Loving God is a process that is free of requirements but that is all the more consuming in its surrender to the Whim of God in the nature and image of the Beloved.

Slavery to the Will of God, Awakened life in the mood of Enlightened and Sacred Ecstasy *as* Love or *as* God is *essentially* free by its transcendent and non-dual existence but is bound by the Law and the Great Process of Divine Evolution. Loving God is apparently bound by the return to duality and the absolute nature of the Lover's separate behavior (separate from God by virtue of Loving Him, Beloved, as object) but is free of the binding of demands to serve any (even the world or universe) essential manifestation. The Lover of God is Captivated by the Beloved, surrendered to His Whim. The Lover of God is not *required* to see only the Beloved, he is not *bound* or *expected* to see the Beloved, he is not at the Will of the Great Process of Divine Evolution (though he usually serves it secondarily and always incidentally) but is consumed in total freedom by the visage of the Adored One. Loving God is pure Gift, it is the *only* Grace there is. It cannot be earned, even by the extraordinary Sadhana of the warriors of Enlightenment. The *only Grace* is Loving God.

It is the job of the Godman to provide the circumstance, the space, and the Divine Influence in all its power, Glory and Mercy, to the devotee or student. The Godman or spiritual Master has an unspoken agreement with all who approach him (her) to shower all such seekers with the Fire of Enlightenment, heated by the surrender to the Will of God and the responsibility to communicate the Ecstatic and enlivening Presence of the Living God and the Great Process of Divine Evolution. The Godman lives to Awaken. He lives, or appears randomly in this Earthly realm, in order to do what he always does in any realm he arises as a manifest being in. He serves this Great Process of Divine Evolution by transforming those who come to him so that their lives encompass perfect sympathy to, and existence as, Just This, this very Process. His "job" if you will, is to move all beings who touch his Influence or enter his Sphere into surrender and Rapture, into Revelatory bliss *as* God.

The spiritual Master, or Godman does not need a corresponding agreement in *intentional* consciousness or willfulness from those who approach him. He assumes that agreement from the beginning of his work and continues to assume it in every moment eternally. So when one approaches the Godman, which in itself is a much rarer event than it might seem in this age of vast numbers of "teachers"

and yogi immigrants from India and Sri Lanka, in this age of great public accessability to attractive and seductive "spiritual" environments and beings, one must approach with a clear understanding of what such a Master's job is.

He will, this devotee, if he allows this Master's Divine Influence to have its transformative and transfiguring Way, surrender to the discipline required of him and find Bliss in his already present Enlightenment. If one *recognizes* the Godman, which in itself is no mean task, such a one will Awaken and serve the Great Process of Divine Evolution. This is the fulfillment of Divine Destiny and will provide the opportunity and the necessary wisdom for the fulfillment of Karmic or human destiny.

But Loving God is another matter entirely! One comes to the Godman in order to be moved into the ecstatic sublimity of God (or rather one is ultimately moved into the ecstatic sublimity of God when one is in communion with the Godman, no matter what reason one came for). One approaches the Godman to ask or seek for His Help, His Blessing, His Benediction. One's Awakening depends on such Help. One's responsible surrender to the Will of God, and enlivened existence *as* the Great Process of Divine Evolution is between the devotee and the Great Compassion of the Godman. But the Godman cannot do anything about, or has nothing to do with, Loving God. He cannot even put in a good word with his Boss!

Loving God is strictly between the devotee and God. Loving God is a matter for the Beloved to consider. The spiritual Master can simply avail one of the Holy Knowledge of such an ultimate *human* possibility. He can be of *no help* in its realization for it is pure Gift. Loving God is between God and the Lover, while Realization of one's already present Enlightenment is a threeway affair, the seeker, the Godman, and God. But in Loving God there are no intermediaries, no spiritual matchmakers. The spiritual Master's Help, or Divine Influence, even His existence *as* Just This, or God, is no help

to the already Enlightened and justly Awakened devotee. The Godman's Presence is itself unspeakably Holy, undeniably Divine but such a Presence Awakens, transfigures, transcends all planes and Loci. The Godman is absolutely no help as far as Loving God is concerned.

Loving God is the *only* Grace there is. And that is strictly between the Beloved and His Lover. It is *only* Gift. The Godman's Influence is sublime, unspeakable, Sacred, Holy, Ecstatic, Transfiguring, Blessed, Benign, Profound, Enrapturing, Revelatory, Infinite and Inclusive. But it is not Graceful. This I must expose. The *only* Grace is Loving God, and that is strictly between God and the devotee or Lover. There is *no* "Graceful" Influence. There is only Divine Influence and Grace, and the *only* Grace is Loving God. Loving God consumes, it doesn't influence! The *only* Grace is Gift, which is Loving God. This is not an "influence" whereas the Godman does offer a very real and tangible and mercifully Transformative Divine Influence. But Gift, offered in a moment, does not "influence" but devours the Lover with its vision. The Lover of God is blinded to all but the thousand suns of his Beloved's Light. The *only* Grace is Loving God. And this Grace is His Gift, the surrender to His Whim and the ultimate *human* expression.

The idea or philosophy of Loving God is certainly not very rare. Many Traditions and many contemporary spiritual schools talk almost constantly about Loving God. But none of that, with the rare exception of some Esoteric Traditional considerations, is of the nature that I am communicating here. Loving God, in the way that I describe, is a completely radical, *absolutely* radical affair. To transpose what love means or has meant in conventional human time onto God-object instead of opposite sex or puppy dog/kitten object simply does not convey nor even begin to embrace or manifest Loving God in its true sense. And this is the error of almost all of the ancient and contemporary versions of Loving God, even those found in some quite reputable traditions. The conventional notion of love, even though it may use such language as sacrifice, care, affection, joy, bliss, and so on is simply a function of man's cultic tendencies to protect his home with a mother for his children and a maid for his castle and then to protect his woman against all intruders even if she invites them in! Man's conventional and ordinary relationship to what he calls love is a neurotic, though at times temporarily satisfying, even greatly pleasurable event. Love, as it is touted in the card and gift stores' row upon row of friendship/love/get well/humorous/valentines/anniversary/condolences on the mange of your dog cards is just a more poetic

form of the same thing that serves the illusion of eternal survival or immortality in this bodily form as in any other form.

Loving God, to be considered in that vein, is absurd. It is an insult to God to simply transpose ordinary and common strategies of survival and dramas of romantic nonsense on to the Divine object or Mythic Character of the Personal Beloved. Loving God is a completely radical affair which burns up the blind and unconscious opinions and forms of behavior that pass as love under "normal" circumstances. Loving God is not simply a peak emotional or even spiritual experience or an energetic and enthusiastic response to someone or something. It is not typified by the naive and superficial expression of infatuation that is so common in sophisticated and civilized societies. Loving God is a consuming affair. One who Loves God does not wear his Lover's qualities on his chest like a medal of honor. One who Loves God is not a swaggering braggart, proud of his "manhood" or hunting ability. He isn't a chauvinist. One who Loves God is absorbed in the beautific vision of his Beloved. Such a one has no time for separative and egoic plays that attempt to make the object of love, even God, into a prize for display at the county fair (in the category of "objects of love that are finally the Real Thing!"). A Lover of God is a slave to his Beloved's Whim. A conventional lover is a slave to his need to glorify his need to be important and recognized for his success in the field of surviving by being "wanted, needed, loved" and so on by someone else.

A Lover of God is a radical human being, a complete Divine Fool. He scares people by the very heat and overwhelming joy of his absorption in the Beloved's image. People tend not to be "happy for" the Lover of God. They fear such total irrationality and unobjectivity, even if it is over God. The Lover of God *is* irrational and unobjective, you see. After all he is a slave to Whim, which is a-Lawful, not logical and predictable, moral and understandable. The Lover of God is one-pointed, focused only on his Beloved,

finding all else, even "good" sense and consideration for the "humanity" of other beings completely irrelevant. Only the Whim of the Beloved has meaning to such a Love-blinded fool. And he has become such a one through Gift. Loving God is the *only* Grace there is. And Grace is always and only involved in radical affairs! Grace is not common, not ordinary, not conceivable to the unenlightened mind and it is only the greatest of *human* possibilities to the Enlightened mind.

Loving God must not be soiled by being equated in any way with the ordinary forms of love or with the conventional concepts of love. It must be seen to be completely radical and profoundly sacred in the Gift of its circumstance. It must be seen thusly because it *is* that. Loving God is not achievable but is possible through Grace, through the *only* Grace there is. Do not be fooled by the silliness of the mind's attempt to persuade you that you love God. Loving God is the Holiest and most Radical of events and it must be seen to be believed.

In the Vedic Scriptures of India, although I think it is safe to assume that there is enough profound knowledge in the Vedas so that we could call them Scriptures of the world instead of "of India," it is stated that one can anger God or curse God or get on God's "bad side" (I am pretty sure that that refers to His left profile) and this can be somehow absolved or made right, forgiven, but one should never, never, never anger or curse the Guru, for that is irreparable.

This statement is a direct reference to slavery to the Whim of God in relation to Slavery to the Will of God. The Guru is considered to be God in many Traditional cultures, with the traditional and lucid wisdom of the spiritually mature. The Guru is to be respected as and treated as and even absolutely considered *as* God. The Great paradox is that the Guru is also human, also ordinary, and also most clearly mortal. Jesus suffered the foolish questions of His disciples as an ordinary frustration. Mohammed suffered the jealousies and competitiveness of His many wives with great patience, integrity, and ordinary exhibition of balance and strength. Buddha, Sakyamuni, suffered the desirings of His monks with the calm detachment of the ordinary outcome of heroic practice. The greatest Gurus were human, and mortal. Yet they were considered God without reservation though of course with some confusion here and there. The cultures of true spiritual

Wisdom accepted the true nature of God through the Divine Influence of the Guru and only when the wisdom of the culture of desire and pride became predominant were these Gurus destroyed or driven into "hiding."

The Guru is human. And whimsy is a very definite *human* quality. God is too Lawful, too omniscient, omnipresent and omnipotent to express *whim*, which is definitely a weakness of character, a lack of direction and decision, and a refusal to be disciplined. But since man is already presently Enlightened and there is a thread of essential recognition of that Divine knowing despite the vast mask of Ego and the born demand to substantiate immortality through the survival of the body in its mortal form, each one intuits this Whim of God, which may very well go against every rational thought it is possible to think, but is True nonetheless. Only a personal God could be Whimsical. So the Guru, who is the symbol or archetype of the Personal God (for he is the only one a human can intuit as Personal God, a human cannot intuit a gerbil as the form of Beloved), is intuited to be the expressor of Divine Whim. He is instinctively recognized to be the closest possible connection or reference to the Beloved, so the Guru is placed even *above* God by the Vedic Scriptures.

This is the implication, not the essential Reality of Enlightened vision or Revelatory knowledge.

The Personal Beloved can only be recognized, whether Gift is offered and received or not, even recognized to exist at all, *after* one has recognized, through complete submission to and functioning *as*, the Great Process of Divine Evolution which is God and the Will of God all together. The Guru, who is God *and* human, Divine *and* just ordinary, Sacred and untouchable, unapproachable *and* mortal and a fool, is looked at in the Scriptures as even more "dangerous," more crucial in the affairs of Man, than God itself. Because of the Guru's humanness, it is intuited that He could express Whim, which intuition communicates would be the Whim of God, which is a terrifying notion to the rational, non-dual realization of

Enlightened truth and essence. But God's Whim is True or rather the Beloved's Whim can enslave the Lover through Grace but God's Whim to the Slave to the Will of God is profoundly disorienting and confusing while to the unenlightened one God's Whim is simply incomprehensible and even considered Demonic in its manifestations.

To the man who is Awake, the Whim of God is comprehensible but wildly uncommon and disturbing but to the Lover of God who has been Gifted with the *only* Grace there is, this Whim is his delight and his joy. The Whim of God is the Lover's delight *because* it is *Whim*. The Lover accepts the Law because it is undeniable and True. It is THE LAW after all! Yet he still delights in Whim of God because it is the Beloved's Freedom, not His Divine Task. The Lover of God is a slave to his Beloved's Whim and understanding of his Beloved's nature or *essential* activity, which is the Great Process of Divine Evolution. But it is the Beloved's Freedom which is manifested in the spontaneity, the a-Lawfulness of His Whim.

The Guru, in human form, is the symbolic representation of the possibility of Divine Whim, as Whimsy is certainly a wild and Free demand to every *human* being's linearly conceived ideologies of God and spiritual life. We expect and allow, at least if we are not completely deaf and crystallized in consciousness, Whim to be expressed in small children and retarded ones but are conditioned (trained) to quell this aspect of our nature as adults because it is too immature, uncontrolled, illogical, impolite, or useless. We are enslaved to the great god of technology and manners, of protocol, at the cost of true cultural communion with God and Nature. But we also intuit, sometimes this intuition being the cause of great frustration and unhappiness, that "as below, so above." That as we are whimsical beings by nature, so too does God have a Whimsical streak. And it is a *Human* quality that God shows us as His *only* Grace. Animals are *never* whimsical. Have you ever seen a whimsical worm or a whimsical aardvark? To be a

Lover of God is the ultimate *human* possibility and to be a slave to the Whim of God, therefore clearly recognizing and understanding the Personal Beloved, even through Love, is a *human* relationship to the Beloved. When an emu finds the Beloved his relationship is quite different, you can be sure! An emu isn't a slave to God's Whim, believe me!

But the *human* Lover of God is called to this slavery, slavery to the Whim of God. The Guru advantages the devotee through his (the Guru's) very humanness. The Guru *is* Divine Influence and offers the power and glory of Awakening, but he isn't the Personal God known as Beloved. The Guru is the reminder of God's Whim to the human world, and such is his inconceivable Grandeur.

One of the saddest effects of a life separate from God and unsurrendered to His Essential Being, is the lack of trust between human beings. We really do not trust one another, even in the midst of the most "loving" and personal relationships. We exhibit all kinds of superficial trust, or "selective" trust, trusting where money is concerned but not where sex is concerned or trusting where sex is concerned but not where diet or business is concerned, and so on. But the reality of things should make it very plainly clear that we do not trust other human beings in a very deep and meaningful way, nor with any consistency. In fact it is more common to trust animals, dogs and cats and gerbils, by the average man, and even tigers and lions by some, than to trust other human beings. To say that dolphins are inherently "trustable" and that humans are not does not address the essential problem. Our lives are empty and painful, always slightly on edge even when we ostensibly are completely successful, because we do not trust one another beyond the superficialities of social convention.

The concept of Loving God, the deep and penetrating investigation of Loving God is crucial in this Way because one of the most dramatic considerations of such an investigation is its obvious indication and communication about trust. To be surrendered to the Will of God, to live one's Enlighten-

ment, to exist *as* Love itself, does not require trust at all, though it may inspire trust incidentally simply because it *is* the truth of the Great Process of Divine Evolution. Being a Slave to the Will of God, being surrendered to the movement of the Law in every moment leaves no room for alternatives or doubt or suggestions to God for improvement. In such an absolutely Divine, yet inclusive existence, trust does not enter into it at all! The Will of God is the *only* possible dimension of function, even if the possibility of manifestation is infinite, it is infinite within absolute Slavery to the Will of God in every moment. The Will of God is *always* Lawful, eternally and Divinely real in every instant of time and every single facet of its creation. There is an infinite possibility of manifestation seen over time and space, but within the moment, there is no possibility of variance for that moment. The Will of God is predictably true to its own undeniably perfect Process, you see.

But the Whim of God is a-Lawful. It is, or at least *may* be (and may not be since it is totally and freely Whimsical, that's the point!) spontaneous, unpredictable, Graceful, wild, untrue, illogical (from the perspective of Divine Logic), even completely useless and foolish in relationship to the Great Process of Divine Evolution. To Love God, though one cannot do it but must be revealed in it through Grace, through Gift, requires the most profound trust. Being a Slave to the Will of God is natural, obvious, all-encompassing in its nondual expression. It includes trust in its inclusiveness but does not require trust in the midst of relationship for the Will of God may *be* relationship itself. We exist as mortal human beings in a world in which trust is so deeply necessary to the process of *relationship,* though it may not be necessary to the process of Enlightenment at all. This earth exists, like it or not, and we are dualistically *designed* and existent, like it or not, so the ultimate *human* possibility is a dualistic one, and a specifically *human* one, not a Divine one. The ultimate Divine possibility is already always present. The ultimate *human*

possibility is *not* already always present because it is Gift, the *only* Grace there is. We, as human beings, are *already* Divine, *already* Enlightened, *already* full of and bound to our various destinies, Karmic and Divine. But we are *not* already ultimately human. That is the *only* Grace there is, God's one Gift: Loving Him as Beloved.

And to exhibit *humanness* in this world, to any degree of truth and with any degree of real ease, demands trust. An even cursory consideration of the "good news" of Loving God, of the observation of this Gospel of the Whim of God, must show anyone that to be a slave to Whim, *even* the Whim of Almighty God Himself, requires a degree of trust unheard of in any ordinary sense. One who Loves God trusts by the very nature of such Love, but the intense and studious perception of my considerations, will communicate a Divine Revelation about trust itself. We must trust one another, even to the point of trusting the essential race of human beings, if we are ever to live in real community and develop any sort of educational and cultural setting in which the Great Process of Divine Evolution, God, can be lived, communicated, and ecstatically Worshipped in a way free of the obstacles of societal prejudice, cultural biases, small minded and exclusive thought and repression, free of argumentativeness and pettiness, and free of the common egotistical reactivity and emotional cramps. One must trust one's Teacher, the spiritual Master, one's children, families, friends, and the Sangha.

The entire consideration of Loving God is so deeply associated with trust, so inherently and tacitly woven into the very texture of this consideration itself, that intelligent and ardent attention to it can only be a Holy benefit, a Benediction. The Whim of God is so Radically, yet Divinely Whimsical, that even to hint at it requires great trust, and great imagination!

Trust is one of the most basic and preliminary forms of human relationship, so basic that almost any Enlightened

communion, of Enlightened or "unenlightened" beings, rests on it. The Whim of God is not subject to "back seat drivers." One must be at least calm enough or have enough presence to sit back and enjoy the communion with the driver without feeling the need to point out the brake every few moments (or to carry on a running monologue about how to drive, safety, or turning signals). Trust leads to Wisdom and Wisdom is a quality of life that one cannot be human without. Let this message of Loving God at *least* suggest a piercing and surrendered consideration of trust.

It is helpful to recognize that this Gospel, the "good news" of the human possibility of Loving God is not a denial of the obvious truth and essential reality of non-dualism and the inclusiveness of the Great Process of Divine Evolution. This consideration, Loving God, is the major aspect of my teaching work, the message I have appeared here in the incarnation on Earth to deliver. It is not a summation of my teaching work of the past several years nor is it a progression nor a regression of the essential communication I have made thus far in my teaching work. It is not a denial of the truth of what I have already spoken and will speak, nor does it discredit the progressive dimensions of the technical or yogic aspects of my work. This Gospel of Loving God is not an advancement upon non-dualism. It is simply distinct from, a distinction in human terms in relationship to, the obvious expression that all that appears and disappears, that exists and does not exist, that is and that isn't, is God, arising as the Great Process of Divine Evolution: The "good news" that I bring is that *in spite of* the truth of non-dualism and *in spite of* our very nature *as* God, it is possible to Love God which is the epitome of *human* possibility. Loving God is not the culmination of human destiny or life. Awakening into our Divine condition with the help of the Divine Influence of the Godman, living an Enlightened life, surrendered in each mo-

ment to the one Law, is such a culmination of human times and existence. Loving God is the epitome, the Holy acme of human possibility, not the culmination of endless incarnations leading up to the knowledge of and existence as the Truth of God in the form of His Being as the Great Process of Divine Evolution. The highest destiny of man is Awakening, the highest possibility of man is Loving God. Loving God is Gift, the *only* Grace there is. Destiny is preordained, fated, even though the means of "arriving" at or realizing this destiny involves some degree of "free will" and some degree of "chance" within the boundaries of the beginning and the end of our journey from sleep to wakefulness. The end is already assured, even already present, already attained. But Loving God is not fate-ful at all, it is pure Gift and many achieve the Revelatory Rapture of complete surrender to and life as, the Great Process of Divine Evolution and move on to some other plane of existence or some other dimension without ever Loving God. Grace is not necessary! It is Grace, not some bank account that can be called up upon demand. It isn't our due, we aren't "owed" Grace, it is Gift, *only* Gift. Such a one does not "have to" reincarnate as a human being once again to complete his human experience. To "leave" this place having never Loved God is simply not to have received Gift. One can complete one's humanness in line with the Law, Destiny, and the Great Process of Divine Evolution, and not Love God. Grace is Gift, it is not a requirement of incarnations, it is not a reward for good behavior (or for lack of bad behavior, which is what most people call good behavior). We are already That, God, and realizing it is a function of surrender, or pure luck, not Grace.

So this is my message. Realize God, live a life of Divine Passion, devotion, prayer, service, Ecstasy, Rapture, Revelatory Realization and surrender, submission to the Law through bliss. And consider profoundly the possibility of Loving God.

In 1921, Mahatma Gandhi was discussing the inhuman practice of class distinction, or the caste system, in India, particularly in reference to the Untouchables, who were deeply prejudiced against by all other Indians, completely illogically and often at times violently and compromisingly. He said, "Inhuman ourselves, we may not plead before the Throne for deliverance from the inhumanity of others." Historically he was suggesting that those who asked God to free them from British rule and British inhumanity to Indians, while they themselves continued to be highly inhumane to the Untouchable classes were blindly wasting their prayers and in fact were being selfishly unconscious. Mahatma Gandhi was suggesting that God is no help to the world, unless that help is expressed in and through completely *human* beings and in *human* terms. He was suggesting, if I may be bold enough to be in sympathy with his understanding, that God is not the salvation of the world because the world is inhuman and an inhuman world has *no recourse* to the Divine. The Divine, or God only, responds not as a great and kindly father helping his children but in the *form* of human possibility or ultimate human capacity. God doesn't "help" humanity with thunderbolts and lightning, with magic, but with the human expression of Divine qualities towards other human beings. God serves in *relationship*, in the interaction between individuals

and individuals and things, not in some mythical and super-
natural way.

In light of this suggestion, I would like to add that it is not
God Who is the Salvation of human existence, it is the Lovers
of God. To God, this expression of manifestation, this human
sphere or plane is not more necessary or relevant than any
other sphere or plane on which there are beings capable of
self-reflection and intentional surrender to the Great Process
of Divine Evolution (of which there are *many!*). We, mankind
and this entire Earth/solar system/galaxy/universe, could
easily become fertilizer of a Divine sort, or of a quite mun-
dane sort. We could be food for the Law, Sacrificed unto
God's Will or we could just be shit. But because there have
been Lovers of God, His Gift has been the source of our con-
tinued existence. It is not that we exist *by* Grace, but that
Grace allows random human beings to Love God, and this
ultimate *human* expression demands and receives the *Help* of
God, or continued existence. Lovers of God are the salvation
of the rest of us, and God is not our salvation, nor the saints
and sages, only the Lovers of God. God is always already ex-
istent, non-dual, without personal characteristics. God is the
Ground and Matrix of all that exists and continues to arise.
His Help flows or becomes apparent in a manifest way when
the form of life to which the Help comes has exhibited the
greatest possibility of that particular form. Destiny is irrele-
vant and already complete in any case. We must honor the
Teachers who make available the Awesome Divine In-
fluence. We must honor the Saints and Sages who present the
Glory and Mercy of God. We must be deeply Grateful for
the Embodied Presence of the Great Process of Divine Evolu-
tion in the personal form of the Guru and thankful for the ex-
amples of surrender to the Law that are alive as Spiritual
Devotees. But we must also recognize that Lovers of God are
responsible for our actual continuation as a race and as a
planetary, even universal, culture. Saints and Sages, Divine
Men who express the literal existence *as* God are responsible

for the Realization of our destinies, human or Karmic, and Divine, are responsible for the pervasive Divine Influence that surrenders and sympathizes us to the Great Process of Divine Evolution, but they are *not* responsible for our salvation. Lovers of God are of no practical help at all but they *are* our salvation. They simply are our Salvation.

Those who have transcended humanity, which is the true condition of one who is Awake, alive in his or her Enlightenment, cannot presume to ask God for human help. Such Holy beings are at the Slavery of the Will of God, not in a relationship to Him that encourages a dialogue. They have become That. One who has transcended human terms, though he or she will paradoxically continue to manifest for some period of time, is Slave to God's Will, not Master of God's attention and expression. The Slave to the Will of God cannot ask for a boon, even if the boon is to continue the very existence of Earth and the human race. Such a one has transcended all of that kind of involvement and interest!

But Lovers of God have the right, are given the right through Gift, to petition God. And they are heard! Our survival is evidence of their Prayer. The Awakened one has become God. The Lover of God has returned to his humanity and been Graced with Loving God as Beloved, as Other, as Divine Object. He has been given Gift from the Great Bestower of the *only* Grace there is. He has been given the only thing that God can bestow which is ultimately and perfectly *human*. This does not preclude the Lover's Divine Essence and surrender, for Loving God ends when the humanness ends, at the death or dissolution of the body, the human vehicle and distinction.

So one *is* God in any case, already Enlightened but perhaps simply playing out some form of destiny. But only the rare, rare few who Love God are Blessed in their Salvation of the continuation of this Humanism. This is no light responsibility, as you may well consider.

One absorbed in the ecstasy of Divine Realization may appear "drunk" or intoxicated by the power and light of God, through states of Satori or Samadhi. Such a one *is* that drunkenness. Such a one is not separate from or distinct from that drunkenness. Such a one *is* that Ecstasy itself.

A Lover of God may also appear "drunk," but his intoxication is because of his Love for the Beloved. A Lover of God is not identified *as* that drunkenness, he is feeling, knowing, reflecting the Beloved which causes him to be "drunk" with Love.

The Divine Ecstatic, the Mystic is the very expression of Blissful possibility or ecstatic potential through surrender to God which becomes That which has been surrendered to. The Lover of God gets "drunk" from drinking the Wine of the Beloved's form, he doesn't exist as that condition, he is brought up to that condition but always remains distinct from it. The Divine Ecstatic doesn't observe his union with God, he is that union. The Lover of God's drunkenness is a *result* of his separation from God, not a result of his union with God. The Divine Mystic seeks union, the Lover of God is most grateful for his separation, even seeks to assure that he will remain separate, union being the dissolution of Loving God in the obscuration of the Lover and Beloved in One. The Divine Mystic contemplates, meditates on union, the Lover of God

cherishes separation, for that separation is the source of his drunkenness. This is the Lover's pleasure, the contemplation of the Beloved's form, face, separate and personal existence. The Lover of God has been reborn out of union, reborn into separation once again, but not to suffer as the common man but in order to Love God from that separateness. Such is the power of his sacrifice and such Loving God is the profundity of his Gift, of the *only* Grace there is. Is he to be pitied or is he to be praised, this Lover of God?

The real consideration of Loving God is a shattering con-
sideration. Even for one who has deeply studied Enlighten-
ment, and a life surrendered to the Will of God, the very idea
of Whim, of Slavery to God's Whimsy, as Divine as it may
be, shatters the intuition of the safety and security of an
Awakened life of non-dualism and Realized perspective.

Even though Enlightenment is nothing like it is imagined to
be by the unawakened intellect and even though a life of
being a Slave to the Will of God is radical in respect to the
common man's lot, even so, the real investigation of Loving
God and its implications is an absolutely shattering affair. The
placid, or rather Lawful (and therefore predictable) yet still
ecstatic eternality of Godlife is thrown into a kind of wild and
pleasurable turmoil by the knowledge about Whim and
about Loving God. It is definitely an idea that shatters the
comfort of tradition and the inviolability of the Great Process
of Divine Evolution. But such a shattering is good, is
valuable, for it is an opening. It creates a very necessary
vulnerability which makes the culture of one's relationship to
God warm, available, and deeply respectful. Loving God is a
shattering consideration, and well that it is for it should be. It
is a most radical idea and absolutely true.

The real feeling for Loving God will undermine any com-
placency, will totally destroy any security that one has in-

vested in things that are inherently false or illusory. Loving God, the deep consideration of this idea of the Whim of God as the *only* Grace there is, will shatter any egoistic belief systems about Enlightenment, God, or Awakened life that one has surrounded oneself with. Not only will complacency be shattered but the possibility of Loving God will not only be entertained in a serious way but will be related to in a context that brings respect, awe, gratitude, and a sort of ever-present excitement to every moment of one's spiritual involvement.

So this shattering of construct is not only good, and beneficial, but actually invaluable. It is to be celebrated at last! Loving God is not a viable attainment, it cannot be gotten, but it is the *only* Grace there is. It is God's Gift to a mankind so in need of such a Grace.

One of the effects, one of the natural aspects or qualities of the Awakened one is Revelatory expression or Divine speech. I am able to know the truth of this Gospel because I am not other than the knowledge itself. Out of the ecstatic Slavery to the Will of God, out of this assumption by the Great Process of Divine Evolution, comes this pronouncement: that Loving God is the *only* Grace there is. To be more specific, it is the *only* Grace there is in the world of *Man*. Each dimension, each world has its own particular essence and therefore is Gifted or Graced in its own exact way by God. But to us, as human beings, Loving God is the *only* Grace there is, for we couldn't understand or conceive of the "other" Graces anyhow.

Because God has assumed this one, he is able to make this Holy statement, this Holy communication, this Sacred message: Loving God is the *only* Grace there is, and Grace, "this" Grace or any other Grace in any other dimension or world is always Gift, pure Gift, *only* Gift. This is my Rapture, my Divine Message, the "good news" of my ministry. But this is definitely not to imply that I Love God. I do not. Being Awake does not equate with Loving God. Awakening is just Lawful, Just This, but does not insure Loving God nor does it even indicate a propensity for Loving God. The Glory of God is quite evident in the Awakened Man, but the glory of

Man, Loving God, is only evident through Gift, not through submission to the Will of God alone. Even so, one cannot submit to this Will intentionally, with any amount of effort or through any degree of desire or sincerity. And this applies even more so, if that were possible, to the Whim of God. This submission to the Will of God is an assumption by God, by the Law, by the Graceful Process of Divine Evolution. And the submission to the Whim of God is *only* Graceful, even a-Lawful, for it is Gift. This submission to the Whim of God, or rather to Loving God which is slavery to this Whim, is the *only* Grace there is. So I must say that the Revelatory Benediction that is this Word is true of my submission to the Will of God but I have not been submitted to His Gracious Gift, and do not Love Him. God assumed this Slavery out of "His" Great Process of Divine Evolution and once enslaved, I submit myself to this Slavery to His Will in every moment eternally.

But submission to His Whim through Loving Him as Beloved is Gift, not Destiny of any sort and this is not true of me, though I can bring you the "good news" of the Truth of God's Whim. Such is my joy, such is my sorrow.

The rhetoric of schools and teachings of Awakening, of non-dual considerations, is hard, shocking, demanding, and austere. The rhetoric of the true Ways of Realizing Enlightenment is designed to create a profound and always hard demand or shock, for such a situation creates an opening, a vulnerability that allows the Divine Influence of the Godman room to move, a space in which to Lighten the darkness of separative and deluded motivations and beliefs. The rhetoric of all real teachers is fiery, forceful, and even terrifying to Ego, to the prideful, deluded, and self-isolationist "self." The crystallized position of the self-meditative one is in need of a shock that breaks the habitual, chronic pattern or design of this crystallization. Only hard or demanding Sadhana, Tapas, will serve the culture in which Awakening can be expected or assumed. The separative one must be "cracked." His armor must be pierced by God through His Divine Influence in the world so that his already true Enlightenment can reveal itself profoundly enough for him to "be different" even eternally. Usually when one is first confronted with the non-dualistic truth of the Great Process of Divine Evolution, with the inviolable Destiny of Its Willfulness, a great turmoil ensues, both in one's outer circumstances and in one's inner security (as illusory as it may have been, it still was secure in the degree to which it was "bought" or "invested in"). The

archetypical battle between darkness and light is played out in the devotee through the battle between Ego and its attempts to repair the breach in its armor, and to consolidate its deluding ammunition to maintain its illusion of independent and immortal survival (in the identification with and exclusive existence as the mind/body unit personalized as any particular individual or personality) and the Light and Demand of Divine Influence that expresses as Enlightenment or as the Presence of the Divine in Human form, through surrender to the Will of God. This message of truth is neither salvatory, pleasant, easy, or relieving. In fact, this knowledge itself only *points* to that which seems to be ultimately salvatory, pleasant, relieving. But nonetheless this message is Divine and Holy. It is already true, already and only Divinely arising. But it is not gentle, it is hard and uncompromising.

The message that I bring, this Gospel of Loving God, the "good news" of the Truth of the *only* Grace there is, the existence of the Whim of God and the ultimate *human* possibility of Loving God, as a slave to His Whim, *is* a Salvatory message. And it is *also* Divine and Holy, as is the message of the non-dualistic Reality of all that arises through the Great Process of Divine Evolution *as* God. Still, this message, this Gospel is not hard, not demanding, not shocking. It is a message that soothes, glorifies, and absolutely brightens one's eyes! It is a message not of hope, but of pure delight. It is a message not of truth, but of Love, even though it is true, coincidentally (and fortunately!). One has already been "opened," has already surrendered to the already present and Willful force of Enlightenment. One has already ceased to resist, react, cramp, or contract in relationship to the pervasiveness and inclusiveness of the Divine as the Great Process of Divine Evolution in Movement and as God itself in Essence. One has already passed through the turmoil, the fire or inferno of the crisis of Divine Realization. One has already pierced the dilemma of survival orientation and separative distraction and suffering. So the message of Loving God is

only a delight and a celebration.

One is shattered by this delightfully whimsical message, it is true, but the shattering is not like a cup breaking on the floor but rather like the shattering of the waves on the beach, or like the shattering of a glorious firework display that produces in its shattering the most wonderful and beautiful vision. The rhetoric of all real Teachers and schools is merciful, necessary, and profoundly revealing, and is already true. The rhetoric of Loving God is Graceful, *only* Graceful, Gracious. The difference should encourage a deep and searching consideration of Loving God. It is after all, Gift, the *only* Grace there is.

Transfiguration, or the complete submission to and existence as Free Energy, unbound by the limitations and conventions of gross existence, may occur in two principle forms, Light and Sound. At the acme of manifestation, or at the root of creation or arising, Light and Sound are exactly the same, identical in their ultimate expressions. Both are Love or God in its impersonal sense or essence. In all of the stages of expression or levels of relative submission to the Will of God, sound and light appear quite distinct from one another. And in the esoteric significance of forms of Enlightened life, there is some distinction as well.

One who pursues the path of various yogas, tantras, or esoteric practices that are bodily transformative, begins to become purer and purer, less dense as a literal state of being, or become more Light and less dark. There is a bodily shift in the nervous system and its functional capacities from grosser to subtler. All of these processes, when lived as simply appropriate forms of Enlightened Sadhana, not strictly utilized as techniques to make one "better" or less sufferative, eventually lead to a kind of Transfiguration, which is the literal transcendence of gross or "slow" energy in Light or ultimately "fast" energy. The peak of this "fast" energy is dissolution into the stream of pure consciousness, while maintaining circumstantially various forms that are apparent in the world

and in relationship. Jesus Christ, in the described Transfiguration on the mountain, appeared too bright, literally, for the eyes of His disciples. They had to turn away. Krishna, when He showed Arjuna His true form, forced Arjuna to beg for less of a vision, one that he could deal with adequately or "sanely." Yet both Jesus and Krishna resumed a form that to the eye of the uninitiated, *appeared* as ordinary and gross as anyone else's. Yet neither of them, Jesus or Krishna, ceased to be Transfigured, Divine, or existent as Light (Jesus) or Sound (Krishna).

The Lover of God, absorbed in the Beloved to the obscuring of all else, repeats the Beloved's Name as everything, with every breath. Such a Lover of God offers the Beloved his heart, which is engraved by the Beloved with His Name, and which begins to reverberate with this Sound. As the Lover of God continues to simply say the Name of God with his heart, he gradually *becomes* that very Sound itself, in literal terms. Every cell, organ, essence of the Lover of God vibrates as, speaks the Sound of the Name of God, just as every cell, organ, essence of the yogic or Tantric practitioner shines as, brightens the world as Light. The Lover of God is Transfigured *into* the Name of God, the Personal Name of the Beloved. No Sadhana is necessary, for Loving God is the absolute submission, first to the Will of God through being the Law and then to the Whim of God, through Loving the Personal Form of the Beloved. This Transfiguration is natural and automatic. But the Transfiguration into Light does require quite intense Tapas, work, discipline. Loving God is Gift, so cannot be "tried out" as can Sadhana which may be engaged with intention and consciousness.

Transfiguration itself is the *human* Alchemy. The symbolic transmutation of Lead into Gold is the indication of the transmutation of the gross, dense, or unconscious one into the Light or Sound that is God. The bounds of the already Enlightened but un-Realized one are transmuted into Freedom through this Transfiguration.

The effects or manifestations of this Transfiguration, as in the case of Jesus Christ and in the recorded cases of students sitting with a Teacher and hearing the Name of God emanating from his "physical" being, are evident in various ways but the actual Transfigured being is not necessarily distinct in apparent form from anyone else. Once a person's body has been engraved with or imprinted with the Name of God, in a literal sense, every continuation of this vibrational sympathy moves the being into alignment with the ultimate essence of this Name, which is the literal creative power of God Himself, Sound. And Light also is this very same literal creative power or God. Light and Sound are equal but are Realized in very different ways. Light is Realized through direct involvement in an intentional process that is always available. Sound is only Realized through Grace, the *only* Grace there is, through Loving God and through the Name of God being then the consuming focus through Gift. The *only* Grace is Loving God, and this Gift is the literal engraving of the *human* heart with the Name of God, one of His infinite Names.

What is Real about Loving God, or the *Practical* implications
of This Consideration.

In the early days of my Teaching Work, I wildly claimed
all sort of fantastic things about myself! I was moved, more
by a startling and arrogant clarity than by Ecstasy, to pro-
claim the truth that "I am God." As Ibn' Arabi shouted *an'al
Haqq*, I am the truth, when revealed in God, so I too made
sure that "my" Enlightenment, whatever that is, was quite
publicly and dramatically presented. Of course the rhetoric
said everyone else was Enlightened also, but I claimed a kind
of exclusive teaching capacity, based solely on the fact of my
"owning" (whatever that is) or being responsible for or
Awakening to, this Enlightenment, which others had not
done, obviously. The first book published by Hohm Press
had a quote on the cover and a wild, almost insane picture as
well. The quote read: "The work I have come here to do is
the same work you have come here to do. I have assumed it,
you have not." Quite dramatic, no? And the book made quite
an explosive entry into the volatile New York spiritual scene.

I was accepted as an "Enlightened" teacher, albeit quite an
unconventional and even radical one. For a couple of years,
the advent of "my" Enlightenment was proudly represented
in all of the community's public teaching materials and

presentations. My name, when prefaced by or used as a pronoun was always capitalized, as in He this, Him that, and His whateversobeit. The point was made but the approach and response generated was really quite a surprise (really, you know Enlightened people don't know everything, believe it or not).

The approach to "Enlightenment" from a position of assumed suffering, which is the case for the vast, vast majority of all living men and women on the face of this earth (and most likely beneath it as well) is almost exclusively one of, first of all, mere curiosity, since the positionality of un-Enlightenment or goal oriented seeking for Enlightenment cannot possibly understand the gesture of already present Enlightenment, and secondly one of obstruse and philosophical consideration designed more to avoid any real self-work or self-Enquiry than to ostensibly get a useable answer. So I was constantly confronted by questions such as "Who else do you consider to be an Enlightened one?" and others of equally useless and nonsensical mein. The whole implied expression of the arrogance of the profession of Enlightenment as some exclusive category of attainment over and against the paradox of already attained Enlightenment for everyone begs to be considered in useless and even in ridiculous and fantastic terms. Of course the uselessness is only from the perspective of Enlightenment. To the questioner, there is some really important and serious, even if perverse, reason for broaching such questions. And I would generally respond by suggesting a more practical approach (because I was always too stupid, and still am, to answer such questions in a pure non-dualistic way, from a pure non-dualistic context) yet interestingly enough my searching and ponderous philosophical answers, or my Koan answers, were respected and considered though nothing very real came of the considerations, and my practical (like suggestions to meditate, study, or exercise) answers were basically ignored, or attempted with various degrees of irresponsibility, apathy,

or some other built in failure mechanism.

With rare exception, my claims were either accepted with nonchalance, disinterested curiosity, or passion, or criticized with violent reactivity, anger, spite and malice. But amongst those who accepted "my" claims to this exclusive Enlighten-ment, or my Real-Teachership, the approach was almost universally impractical. I was bombarded, in a nice, devo-tional and respectful sort of way, with questions about after death bardo states, astral realms, reincarnation, the nature of the Enlightened one, other Teachers, and such things as "What is it like to be Enlightened, is it like a constant orgasm?" and other innocent but totally useless questions. This was not the fault of the questioners for the nature of my presentation and the community's subtle support of that, demanded the response that it got. Enlightenment is simply not speakable, not discussable, not answerable, not dis-sectible. Yet it asks, when the subject is broached, for speech, discussion, dissection, and answers, none of which are even remotely possible! It is all a wild, big Paradox, that needn't be seen to be believed but must be Seen to be Known.

On the other elbow (just a joke folks, you can go back to being serious again), I must say that I do *not* Love God. This has nothing to do with Enlightenment, it is neither paradox-ical nor somehow other-dimensional. It is very basic and understandable: I do *not* Love God. At the same time I can with great certainty and Truth discuss the consideration of Loving God. Loving God is pure Gift, it is the *only* Grace there is, there is nothing one can *do* about it. But also there is a way to live, in relationship to this consideration. And the way to live is *always* consistent with certain principles, unlike the way to live in relationship to Enlightenment which may vary from the lowest end of the scale to the highest, and anywhere in-between, from the wildest sort of existence to the most passive and renounced or austere sort.

To appreciate and truly consider a life of Loving God, only a particular disposition, which is quite possible for anyone

regardless of born or biological disposition and tendency, serves. The approach to my Gospel (to the "good news" that it *is* possible to Love God and that Loving God is Gift, the *only* Grace there is) that has already become apparent is one of a practical and serving nature. The possibility of Loving God is so obviously Gift, so obviously quite impossible to attain, that to question it with philosophy is absurd and hopeless. I have been approached to offer pragmatic and life-positive teaching about prayer, relationship, health and devotion, dedication, and discipline. I do *not* Love God, but can suggest a life that *considers* Loving God as the *only* Grace there is, which becomes a life of surrender, obedience, and profoundly Transformative prayer and devotion. A life of real service, rather than one of sort-of-service while attempting to pierce, unravel the dilemma/paradox of Enlightenment is the true life of a devotee. And this I can offer, in the form of a teaching that means something and that does not encourage wild and useless speculation, philosophizing, and opinionating. Real service is absolutely tangible, evident, while the bemused search to understand the ununderstandable is completely subjective and nonsensical.

Consider Loving God, the *only* Grace there is, the one Gift of the Beloved, and live a life of surrender, prayer, gentleness, kindness, and of profound reverence for the God of our human possibility, the Beloved of every one. Let me suggest for your discussion; how to live, how to feel the truth of compassion, sorrow, joy, and right relationship, what to *do*. If you want to know about Enlightenment, you must approach an Enlightened Teacher with all of that nonsense, and be satisfied there. I must suggest that I do *not* Love God, and do *not* know a damn thing about Enlightenment. My offering is That very definition, and what a final Blessing it is.

Oh, Beloved!
 Hidden from these tear stained eyes
 Do I disturb Your Bliss with my crying
 Do I wake You from sweet sleep with my pleas
 Do I disrupt Your Dance with these shouts?
Oh, Beloved!
 How foolish of this pauper to think he is
 worthy of disturbing You
 Lee prays, falteringly, that he may pray unceasingly
 Even if never to see You, Dearest
Oh, Beloved!
 It is Your Blessing to this one, just to know he
 hasn't seen
 Yet how foolish to feel he has been Blessed
Oh, Beloved! so says this prideful beggar, Lee

Other books available from Hohm Press:

In the Fire

Relationship with a true spiritual Master is a transforming process that works on all levels of our lives; mental, emotional, physical and Divine. Lee discusses the nature of this "fire" and offers the clarity of direct experience to his students. Various topics, from the most mundane application of sadhana to the subtlest esoteric principles, revolve around the central theme of communion with God and surrender to His Graceful Will. This collection of Lee's talks is interspersed with insightful commentary by senior students which gives background and emphasis to the relevance of his teaching. Of all of Lee's books, this is the most practical study manual for application in all areas of functional life as its directness needs no interpretation and leaves no questions unanswered.

With introduction by E.J. Gold. *Quality Paperback, $5.95*

Laughter of the Stones

Laughter of the Stones is the basic introductory volume to Lee Lozowick's Teachings and to the Hohm Community. It is laid out in two sections, which contain both practical suggestions for sadhana (spiritual practice) and "food for thought" to inspire and fill moments of pondering or contemplation.

Section one is a collection of short statements by Lee Lozowick — "moments of truth" which were generated out of divine consciousness in the course of his Teaching work with students. These "moments" are of the same nature as Zen koans or the verses of the I Ching in that they are microcosmic reflections of higher truth, encapsulated in brief glimpses of poetic consciousness. These aphorisms reveal themselves more deeply upon persistent contemplation, and reflect the design of Laughter as a spiritual workbook, a highly readable and informative tool for self development.

Section two consists of longer essays by Lee. These represent the full range of this Master's Teaching expression: from selfless prayer to piercing wit, from lucid clarity to divine paradox, from the mundane to the sublime. Again reflecting the "workbook" format, these essays are all of an essentially practical nature. Some suggest specific techniques for students of the spiritual Way while others offer inspiration for those moments of need we all experience in the course of our growth.

The resounding theme throughout Laughter of the Stones is that nonduality is the case; we are not separate from our highest evolutionary potential or from God. Lee Lozowick does not stop with this realization, however, for his aim is always to make Truth a practical affair for his students and readers. Laughter is therefore a guide to practical esotericism, a source book of wisdom intended to transcend dogmatic boundaries and make the Presence of God a felt reality for those who partake of its Teaching. *Quality Paperback, $3.95*

The Cheating Buddha

This book includes excerpts from Lee Lozowick's journals during a pilgrimage to India in 1979. Each essay offers a rare glimpse into the mind of an illumined soul, a contemporary spiritual Master. The depth of his reflections is a testimony to the profundity and importance of the spiritual life, and Lee speaks with insight on the sense of dilemma which plagues mankind, revealing principle solutions to that felt void. He criticizes the patterns of motivation which have been ingrained in us from birth and guides us, both by direct statement and by implication, to a higher possibility: surrender to divine Will.

In addition, there are the "moments of truth," potent bursts of wisdom which expand into meditations upon our own ultimate reality. Despite, or perhaps because of, their great depth, they may be comprehended on many levels, from the ordinary rational interpretation of their meaning to the pure crystal consciousness which reflects their inner source. The "moments" act as springboards for our deeper contemplation, and if used properly can pierce the veils of our ignorance in waves of intuitive insight. These brief glimpses of poetic consciousness are grouped like the elements of a Zen meditation garden and offset by striking photographs, many from India, and some of shrines not generally visible to the public. The result is an intuitive, esthetic communication as well as a verbal transmission.

The final portion of The Cheating Buddha contains commentary on some of the esoteric aspects of Jesus' Teaching as well as certain parables from the Old Testament. Sifting through varying interpretations of these Teachings, a contemporary Master has arrived at new meanings for these ancient truths.

Introduction by E.J. Gold, Foreword by Sa'shi (Marco Vassi) *Quality Paperback, $4.95*

The Yoga of Enlightenment
The Book of Unenlightenment

The Yoga of Enlightenment/The Book of Unenlightenment is a study in paradox. Two volumes are here combined in one, and placed back to back and upside down relative to each other. These two books within a book complement each other, and in their wake we are left with a broadened vision of reality, a heightened awareness of ourselves and our world.

Like Laughter of the Stones and The Cheating Buddha, The Yoga of Enlightenment and The Book of Unenlighten-ment are each divided into two sections, with "moments of truth" in the first portion of the book and essays or entries from Lee Lozowick's journals in the last. The result again is a combination of extended contemplation and flashes of in-sight which act as "reminding factors" amidst one's daily ac-tivity. This is not a light-hearted or easy book, however, despite its refreshing and often humorous tone. Lee Lozowick has something important to say and he wastes no time or trivial courtesy in presenting his point. He is direct in his communication, and asks that we draw our understanding out of our own being and not content ourselves with a cur-sory reading or simple intellectual grasping. It is best to read at least one other book by Lee Lozowick first in order to have some familiarity with his Teaching style as well as the subtler communication of his writings. Then the uncommon potency of Yoga can be utilized in a balanced way.

Quality Paperback, $6.95

Spiritual Slavery

In his first book, Lee Lozowick offers the spiritual student infectious and raw Humor and Divine Madness with amazing immediacy. Spiritual Slavery was written in the several days directly following Lee's realization of absolute non-duality. Assuming his position as a profound spiritual influence for our time and culture, Lee declares that we have been duped by well-meaning but misguided conceptions of spiritual life. The dramatic and Humorous foundations of real *sadhana* are laid down in no uncertain terms as Lee confronts our notions of God, reality, hope, the "New Age" and true happiness with rare Power and Insight. *Quality Paperback, $1.95*

Zen Gamesmanship: The Art of Bridge

How Bridge may be used as an invaluable spiritual exercise and tool for self-knowledge. Objective Bridge is a form of true observation and allows direct experience of both essence and psyche. With a complete discussion of basic rules for beginners and "Old Hands."

With introduction by E.J. Gold. *Quality Paperback, $5.95*

Acting God...

In our various approaches to spiritual life we have all tried to go on certain basic assumptions: We are asleep. We are suffering. We need to do something or some things to clear up the condition of our existence. Is this the case? Is this the Real teaching of the Masters? Or is this simply another delusion, deeply rooted in ego's supposed need to keep up from losing out to the immensity of the universe, being lost (Alive) in God? In Acting God, Lee Lozowick once again Gracefully and Humorously presents His argument for living our Enlightenment (God) at once and abandoning deadening positionality that often becomes the student's substitute for Real spiritual life. He announces the good news. Enlightenment is not scarce; survival is not an issue. Living Grace is available.

Quality Paperback, $2.50

Beyond Release

Lee Lozowick's early talks with his students. From the foundation discussion of real death, Lee brings the reader to a deeper understanding of the spiritual process through his personal experiences and relationship with his community. Conventional ways of life, whether mundane or spiritual, seek some form of release from present suffering through the attainment of something else. In this book Lee discusses the relationship to the Living God, which is the ultimate attainment and therefore beyond release. The emphasis is always on Life-level application of spiritual work and the understanding necessary to maintain real integrity. Lee's honesty with his devotees and his down-to-earth communication makes Beyond Release a valuable inspiration for students of any path.

Quality Paperback, $3.95